The Photographic Eye of Ben Shahn

The Photographic Eye of Ben Shahn

Edited by Davis Pratt

Harvard University Press Cambridge, Massachusetts, and London, England 1975

TR
820.5
.S48
1975

Foreword by Archibald MacLeish

There are more ways than one to paint that self-portrait of the artist as the artist which so obsesses our self-conscious age. The artist can face himself in a glass mirror, as Vincent did, and paint the image, mutilated ear and all. Or he can face the world and paint what there reflects his expectation. Ben Shahn painted a reflecting world.

Whenever I think of him, now that he is dead, I see that bombed-out building he painted in 1945 with its bedroom wallpaper naked to the blasted sky and the pale little sad-faced girls on their rope ladders, whirling like archaic angels round and round the light pole in the ruined street—the light pole that has pierced the frame above the picture.

It was always the ruined city he was painting: the city ruined by war, ruined by greed, by hatred, by viciousness, injustice; modern metropolis, urban America. But with Ben Shahn the ruin was never the subject: it was only the scene. It was the landscape, and the landscape was peopled with figures—redeemed by its humanity. It was the gutted house where the whirling girls on those rope ladders—meant, one sees now, for escape from conflagration, from disaster—used those tragic instruments for toys, for play, for soaring flight. What reflects the artist in this picture is not the rubble or the broken walls: any man who lived this century can paint a shattered house. What reflects the artist is the towering pole and the three, free figures circling in the air.

This is true reflection. Ben Shahn's was an inhabited world and what inhabited it was not death, despair, frustration, impotence. What inhabited it was man—mankind: those possibilities. I know this, and not only from his pictures. One winter morning in the year of Shahn's Charles Eliot Norton Professorship at Harvard I set out to find him in his studio at the Fogg. It was a room at the top of the building protected from intrusion by back stairs

v

and crooked corridors where the painter was to paint secure from trespass and I approached it with a sense of guilt. I could have saved myself my careful qualms. When I came to the door it was wide open and the room was full of the winter smell of undergraduates. There was hardly a square foot of the floor left free to walk on and as for Ben, though he was painting it was not in lonely silence. He was shouting at the room with his back to it: questioning and answering his questions for himself; pronouncing judgment and refuting with a brush stroke.

I saw then how it was with him: how he found himself in the world and worked in it. He was not and never could have been that private painter who stands outside his picture and looks in. He was that rarer artist who is himself a figure in the scene. "Myself Among the Churchgoers," he called a painting from about the time of these photographs. "Myself Among the Living" he might have called the photographs themselves. It would have placed him where he wanted to be placed—where he belonged—not only in the ruined city but among the human throngs who still can hope there and still live.

Preface

Ben Shahn was little known as a photographer, even to a public familiar with his paintings and graphic work, until the 1969 exhibition *Ben Shahn as Photographer*, at the Fogg Art Museum. The exhibition attempted to place Shahn, a sensitive photographer, in proper perspective and to reflect his consummate skill in the medium. Shahn was more concerned with content in a photograph than with technical qualities; the latter, he felt, had been greatly overemphasized. "When you spend all day walking around, looking, looking, looking through a camera viewfinder, you get an idea of what makes a good picture. What you're really doing is abstracting the forms" (1944).

Ben Shahn was a photographer as surely as he was a graphic artist and painter. He never wholly accepted photography as art, however, and the "whole artistical approach to photography," as he put it, was alien to him. Often he expressed an ambivalence about the medium: "I am only interested in photography as a means of documentation and to make notes for my future paintings" (1946); "I felt the function of a photograph was to be seen by as many people as possible. I felt the image was more important than the quality of the image—you understand?" (1964). Photography was a creative medium as far as the mind was concerned, but expressively it could never attain the stature of painting.

Certainly Shahn was not the first painter to make use of photography: one recalls Degas, Cézanne, Eakins, and Sheeler, among others. Often he would use a reversed photographic print as a model for a painting or drawing, and some of his photographs are clearly "notes for future paintings." Others as social documents stand on their own. Shahn's vision as a painter surely had an influence on his photography. In a 1946 interview he said: "I am a social painter or photographer. I paint or photograph for two reasons: either because I like certain events, things, or people with great intensity

or because I dislike others with equal intensity . . . But frankly, I find difficulty in making distinctions between photography and painting. Both are pictures." His widow, Bernarda B. Shahn, has written: "He felt that photography was a great and valid form of expression . . . He believed in photography used to record . . . He believed very much in its power to discover and reveal."

Although he had long been interested in photography, it was not until 1932, when he was thirty-four, that Shahn, having received a new Leica from his brother, began to photograph seriously. He learned much of his craft from his friend Walker Evans, the photographer; they shared a flat in Greenwich Village and often spent time together in Truro on Cape Cod. Recalling those early days, Walker Evans said: "Ben was a born graphic artist and craftsman. It wasn't very difficult to teach anyone as bright and gifted as that—a very gifted artist—really a poet."

Shahn had also met the young French photographer, Henri Cartier-Bresson, whose first exhibition at the Julien Levy Gallery in New York in 1933 impressed him deeply. Cartier-Bresson's genuine sympathy for people and his remarkable skill in crystallizing momentary aspects of reality had a pervading influence on Shahn's work. Other photographers whom he admired were Matthew Brady, Atget, and Lewis W. Hine, whose compelling documentary photographs of child labor and slums are well known.

During the years from 1932 to 1935 Shahn familiarized himself with the capabilities of the 35-millimeter camera. He was in the vanguard of those photographers in America in the early thirties who used miniature cameras for creative professional purposes. He was attracted to the convenience and unobtrusiveness of the small camera. Often he used a right-angle view finder, which made formal composition difficult and sometimes resulted in severed heads and bodies; however, this device permitted him to record his subject unaware and added a powerful spontaneity to his pictures. He appreciated

the camera's ability to record swiftly moving events: "What the photographer can do that the painter can't is to arrest that split second of action in a guy stepping onto a bus, or eating at a lunch counter" (1944). And he was intrigued by the accidents of design that occur when one uses a small camera. As Ron Hill points out in an unpublished thesis, "With a rangefinder camera, the image . . . the photographer focuses on is not exactly the same image the camera is seeing . . . Consequently, it is not until he views the print that he becomes truly aware of the design seen by the lens."

In 1934 and 1935 Shahn and a painter friend, Lou Block, collaborated on the Rikers Island Penitentiary mural project, which unfortunately was never accepted. To make studies for those murals, they photographed extensively on New York's lower East Side, documenting street life, including labor demonstrations. Later they photographed life in several prisons in New York State. These photographs often lack an intimacy with the subject matter that was to become so apparent in his later work. Many have the feeling of sketches made in haste, but some were quite successful as early attempts at image sequencing.

From 1935 to 1938 Ben Shahn worked for the Farm Security Administration as an artist, designer, and photographer, along with Walker Evans, Dorothea Lang, Russell Lee, Carl Mydans, John Vachon, Arthur Rothstein, and others. Often he traveled with his wife, Bernarda. Their mission was to photograph what F.D.R. referred to as "one-third of a nation ill-housed, ill-clad, ill-nourished." Later they also photographed government homestead projects and made sociologically oriented studies of American small town life. Shahn took over six thousand photographs in the South and Middle West. Roy Stryker, who headed the program, has recalled his impressions of Shahn's work during this period: "I was taken by Ben's photos because they were so compassionate. Ben's were warm. Ben's had the juices of human beings and their troubles and all those human things. You sensed all those things." Shahn earlier had said, "We had only one purpose—a moral one, I suppose.

So we decided: no angle shots, no filters, no mattes, nothing but glossy paper. But we did get a lot of pictures that certainly add something to the cultural history of America."

Shahn's vision was deceptively simple and direct. Often he effectively employed cinematic sequencing techniques in photographing people or events. Viewed side by side, the images read like a film strip, with long shots, medium close-ups, and extreme close-ups from several different angles bringing the viewer into intimate contact with the subjects. In a 1964 interview, describing an auction he had once photographed, he said: "I looked at it almost like a movie script . . . I'd first go out and photograph all the signs on the telegraph poles and trees announcing this auction, and then get the people gathering, and all kinds of details of them, and then examine the things, and the auctioneer, and so forth."

His early FSA photographs stress a frontality of subject matter and a flatness of space which heighten the graphic impact, as in a poster. With superb intuitive skill, he organized his subjects in relation to their surroundings and within the spatial confines of the photographic frame.

Shahn's comments in 1944 on his FSA experience are revealing: "We tried to present the ordinary in an extraordinary manner. But that's a paradox, because the only thing extraordinary about it was that it was so ordinary. Nobody had ever done it before, deliberately. Now it's called documentary, which I suppose is all right. . . . We just took pictures that cried out to be taken."

Shahn's serious involvement with photography was relatively short. When he left the FSA in 1938 he ended his extensive use of photography, although he continued to use photographs in conjunction with his paintings and graphic work. In 1964 he wrote: "In 1959 my wife and I went to Asia, and I took a camera along to do what I had done years ago—photograph people. I could not get interested in it. I took hundreds of photographs of details of sculptures and monuments. We were in Indonesia. We were in Cambodia,

and I did endless photographs of details—the temples and so on. But no more people. I found it was gone. I still love to look at photographs of people, but I couldn't make them myself any more."

In studying several thousand of Shahn's photographs, one is struck by his remarkable achievement. As the images in this book attest, the photographic eye of Ben Shahn reflects a compassionate concern for humanity. One's confrontation with these photographs is more than a neutral experience; their impact continues to be felt long after the first encounter.

Davis Pratt

Cambridge, Massachusetts
June 1975

Acknowledgments

In 1969 Mrs. Bernarda B. Shahn presented to the Fogg Art Museum of Harvard University some three thousand photographs taken by her husband. She has generously shared with us her first-hand familiarity with his photographs and her reminiscences of the circumstances under which many of them were taken.

Walker Evans was intimately involved in the early planning of this book and participated in the preliminary selection of photographs. His death prevented him from writing the introduction he had planned to contribute. On many occasions, however, he provided vivid recollections of his friend Ben Shahn, which have added greatly to our knowledge of documentary photography in the thirties.

The Photographic Eye of Ben Shahn

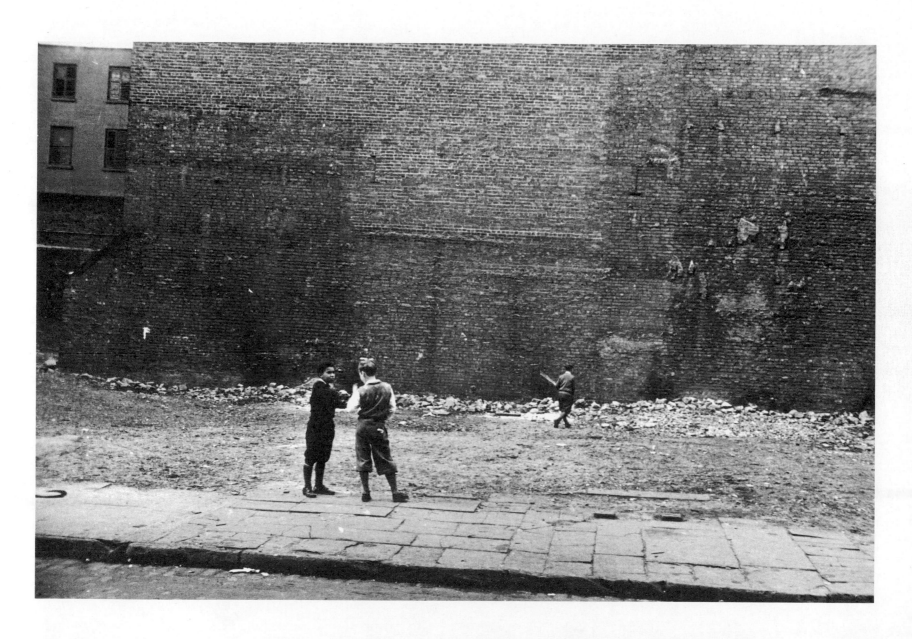

New York City, ca. 1931–32 1

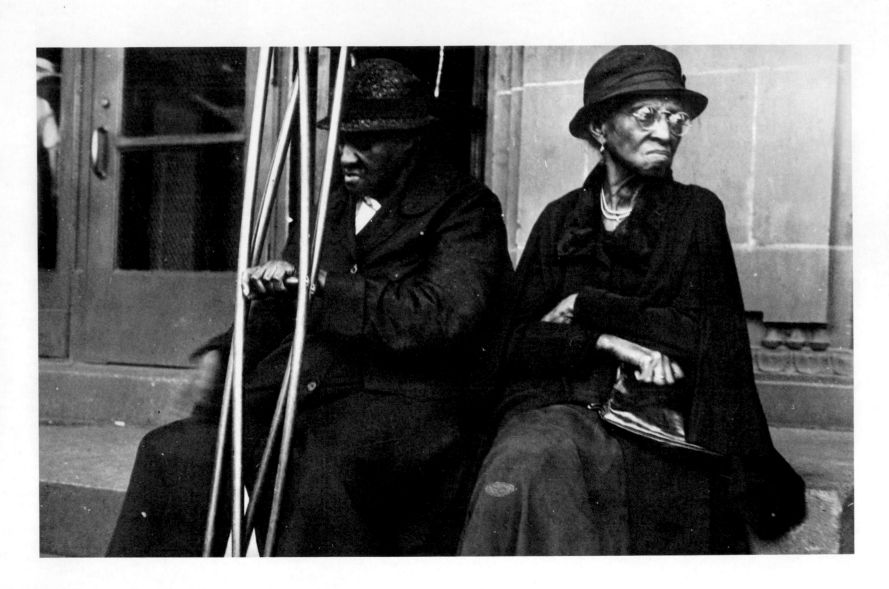

2 New York City, ca. 1932

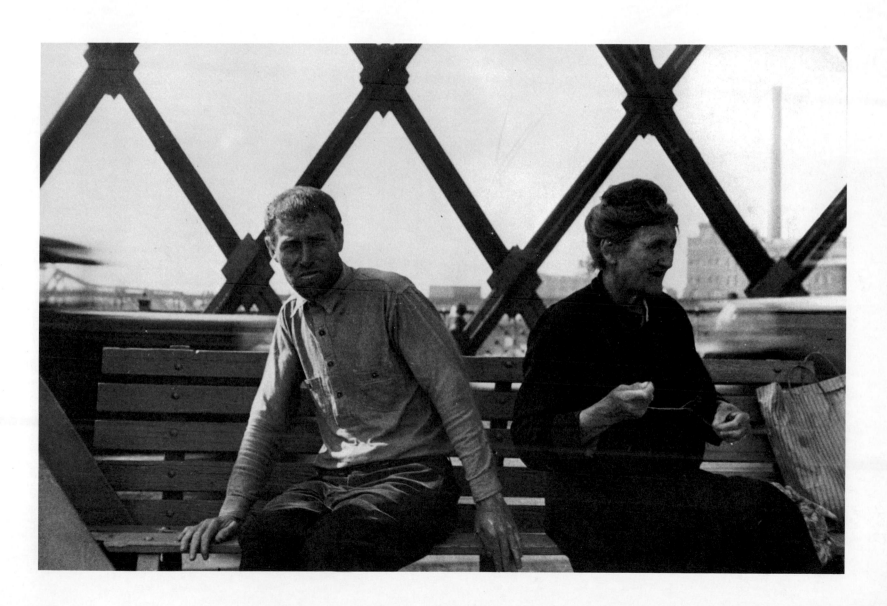

Willis Avenue Bridge, New York City, ca. 1931–32 3

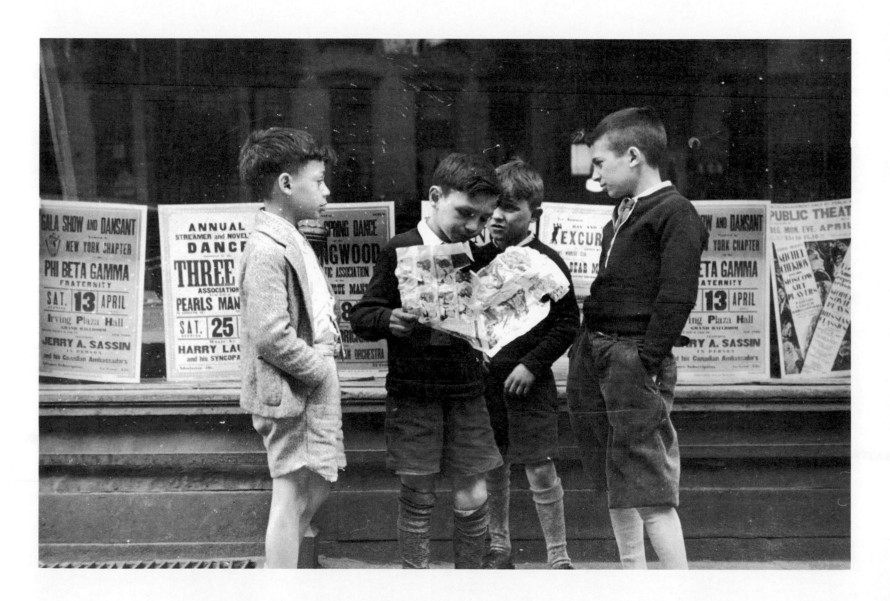

First Street, New York City, ca. 1932

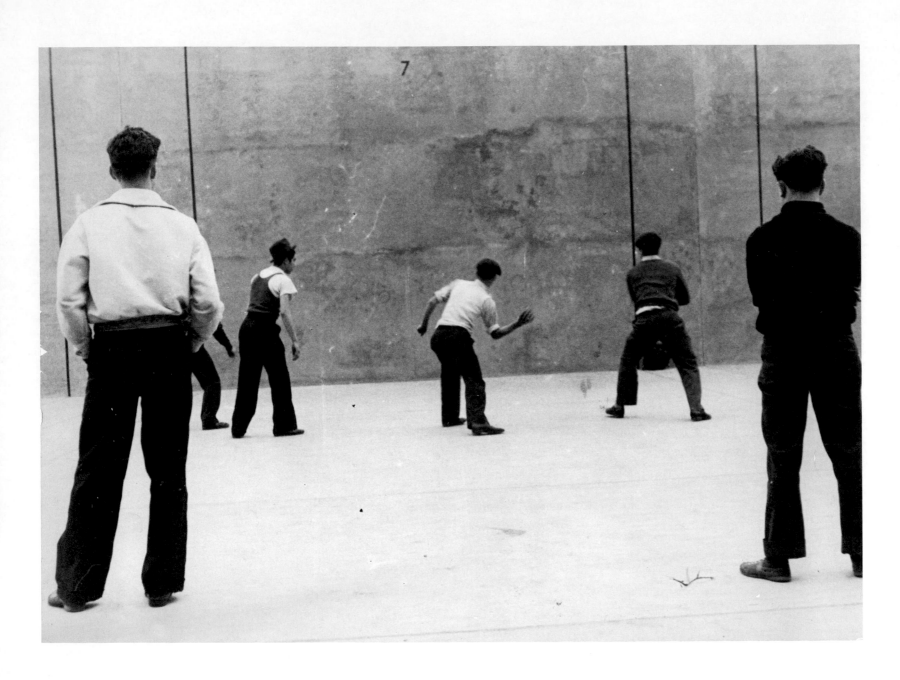

New York City, ca. 1932

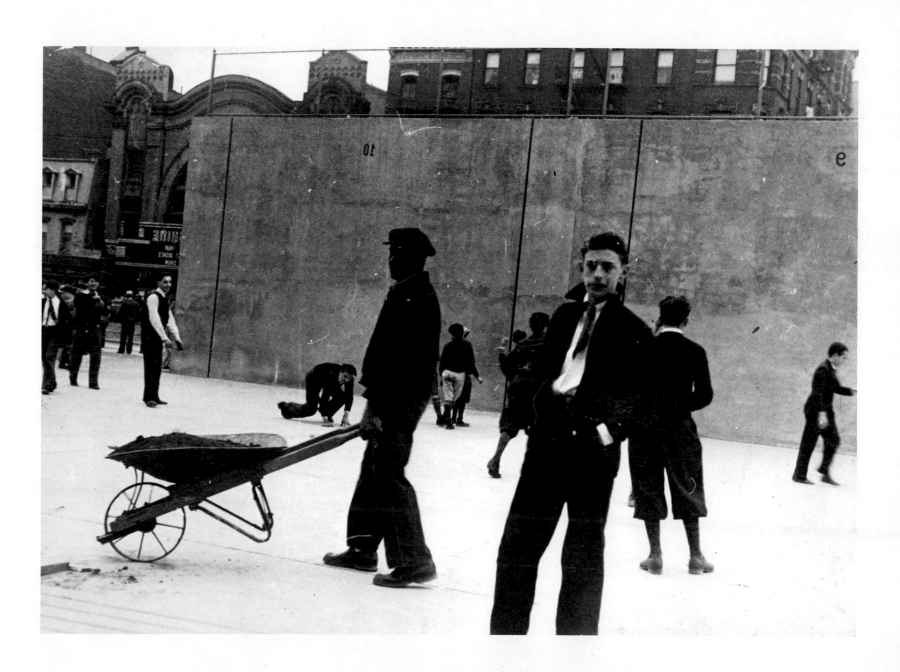

Houston Street playground, New York City, ca. 1932 7

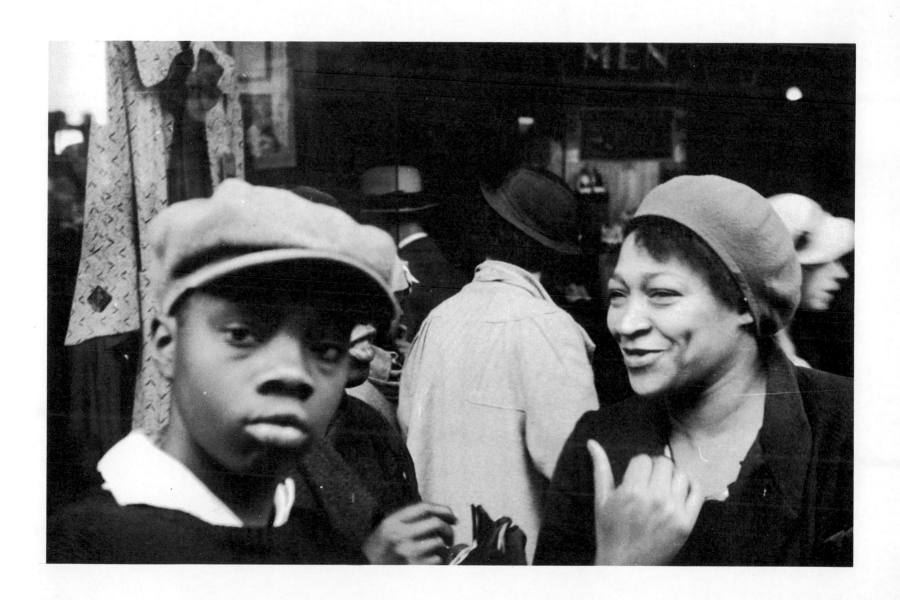

Lenox Avenue, New York City, ca 1933–34

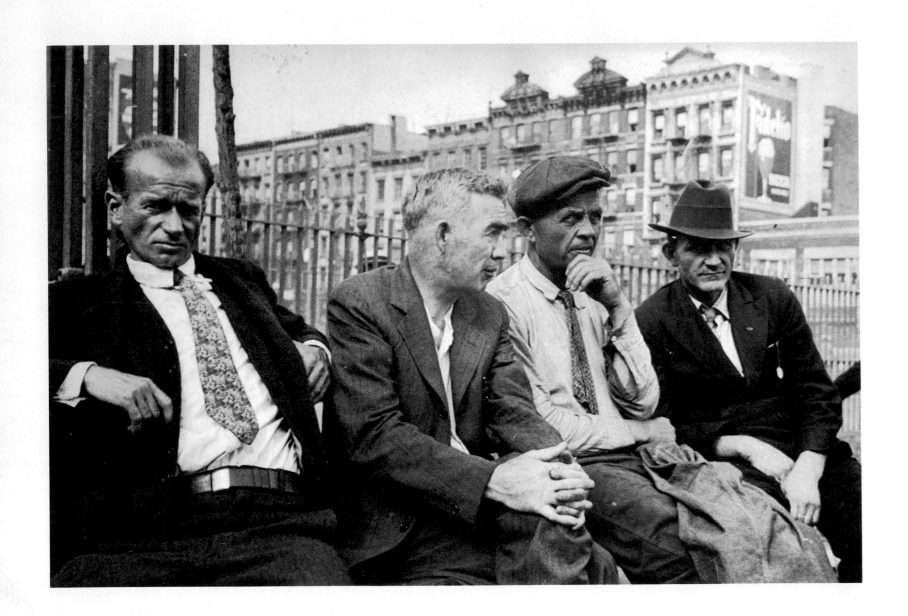

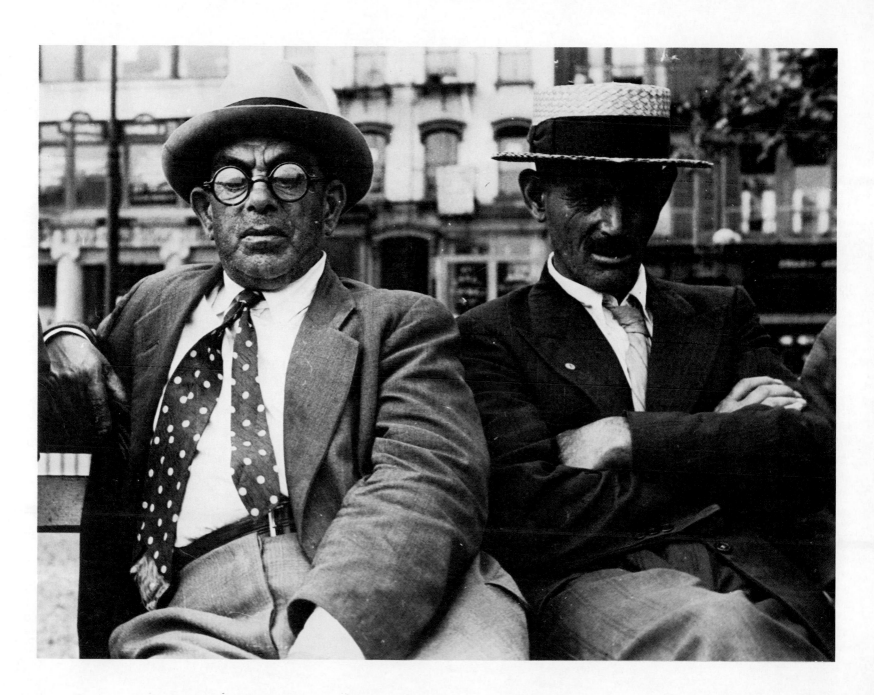

Seward Park, New York City, 1933

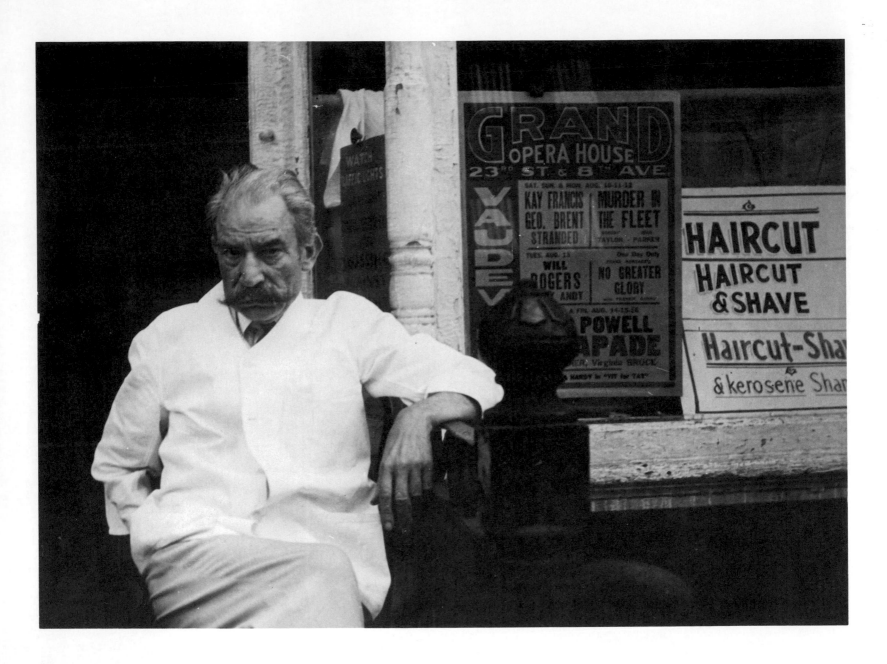

New York City, ca. 1933

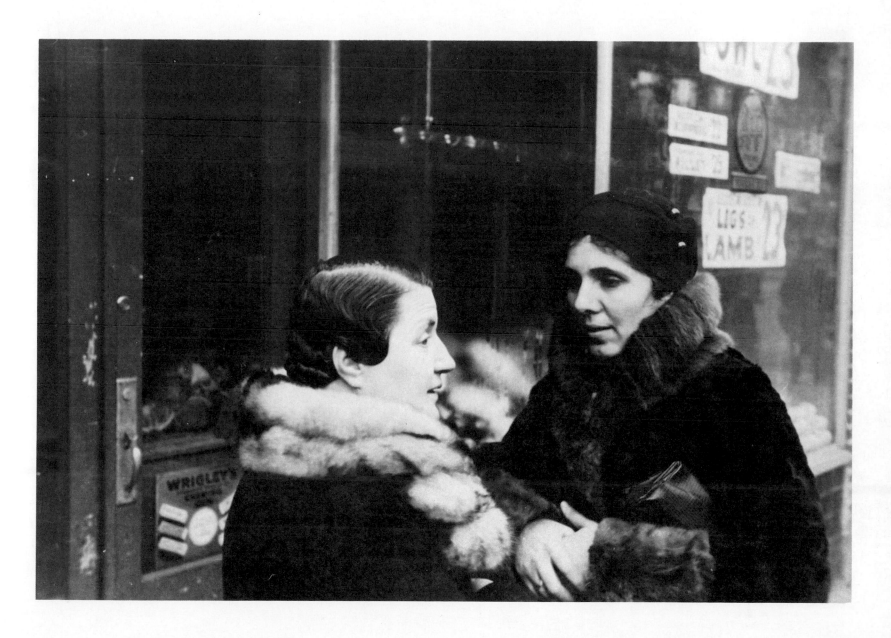

New York City, ca. 1932–33

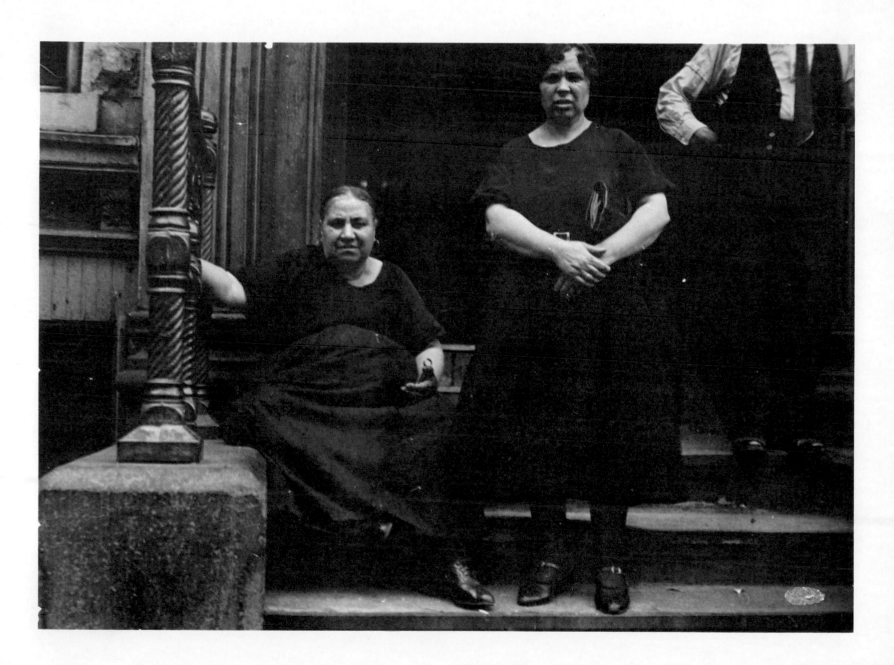

New York City, ca. 1933

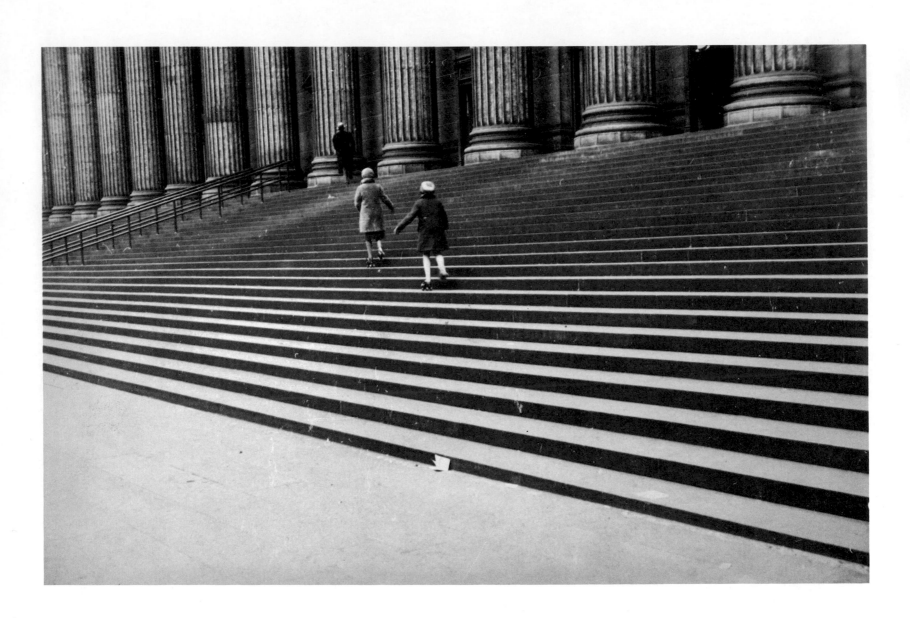

18 Post office, New York City, ca. 1933

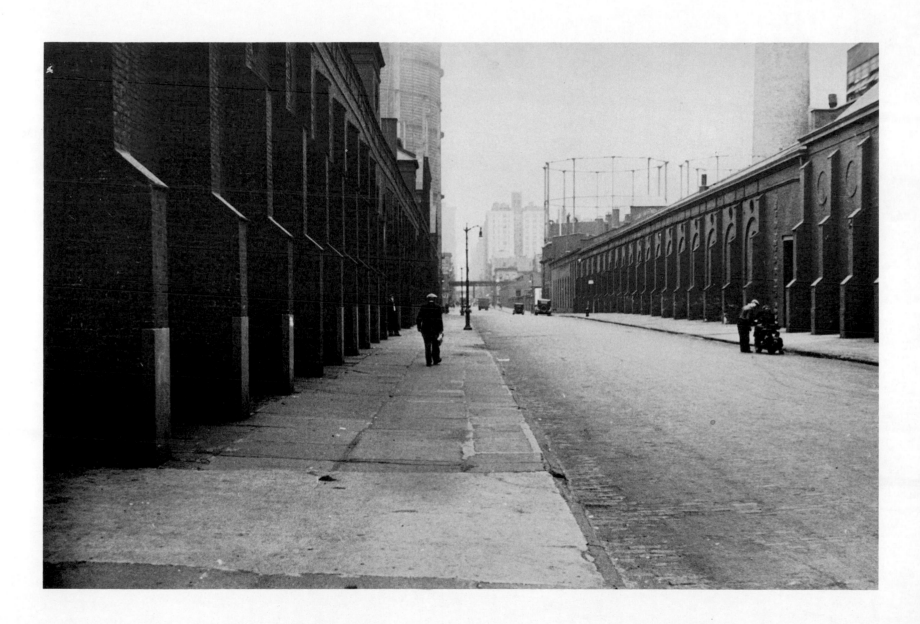

East 12th Street, New York City, 1933

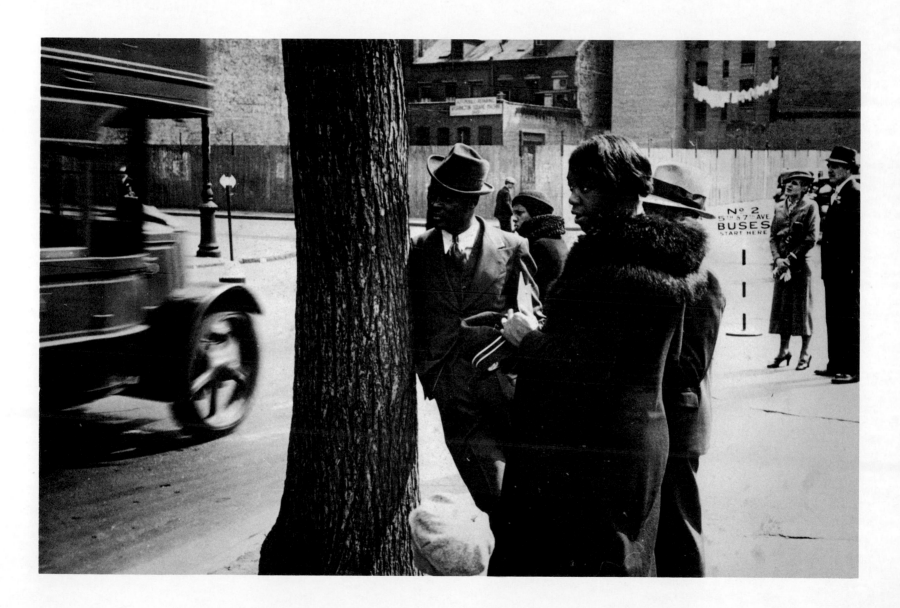

New York City, ca. 1933

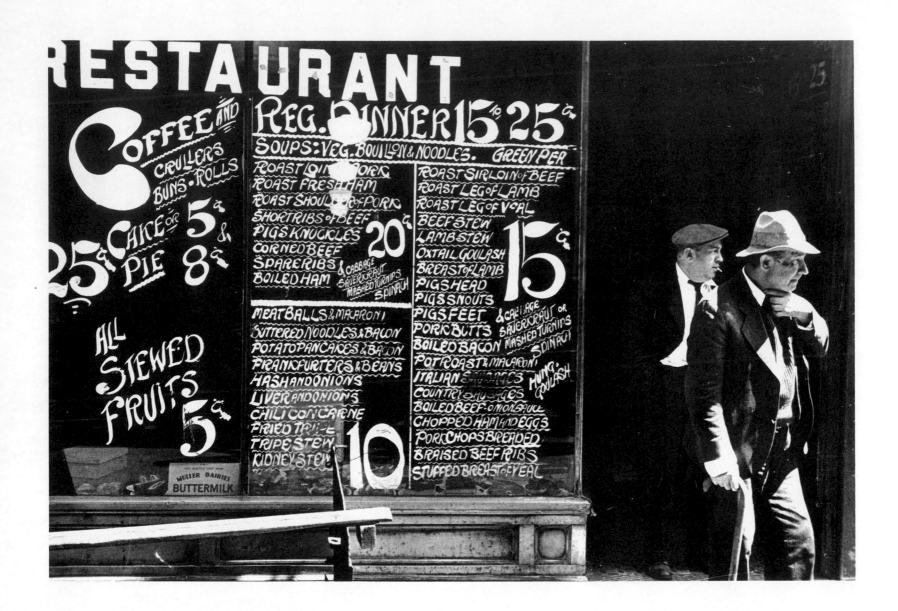

22 The Bowery, New York City, ca. 1936

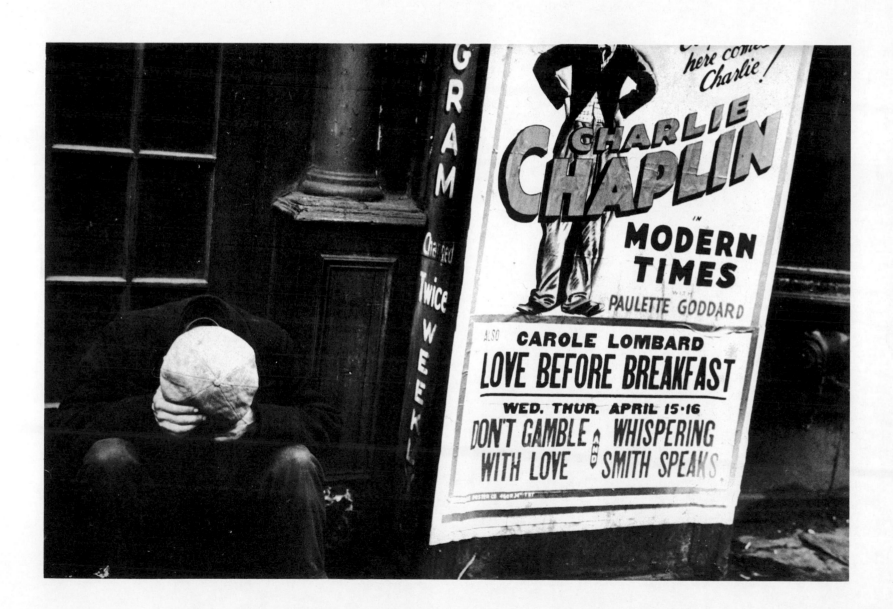

The Bowery, New York City, ca. 1933

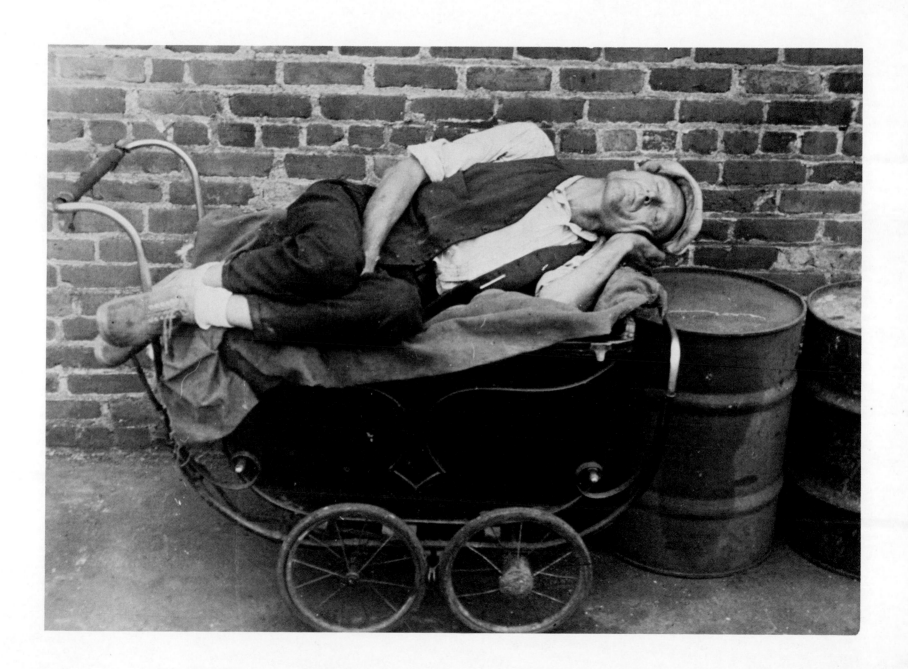

Cherry Street, New York City, 1934

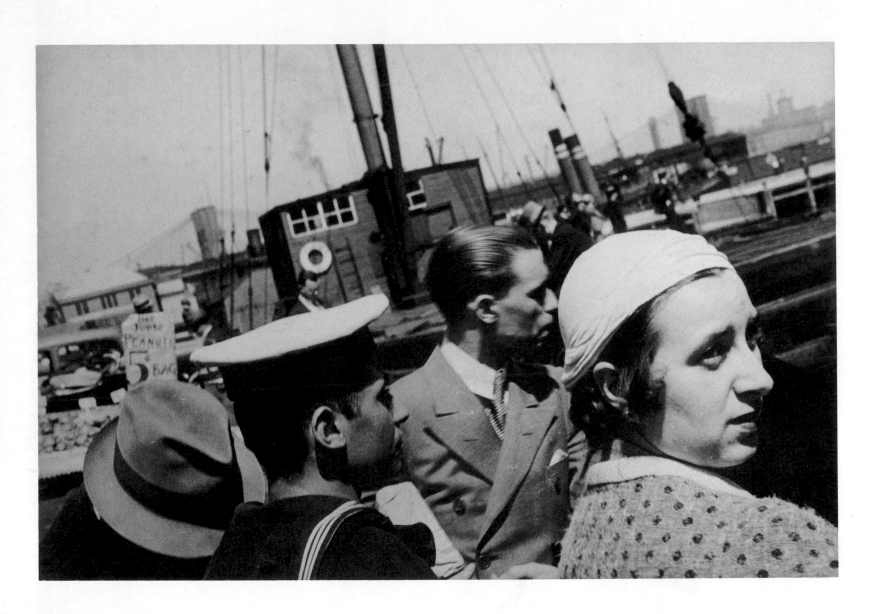

South Street, New York City, ca. 1933

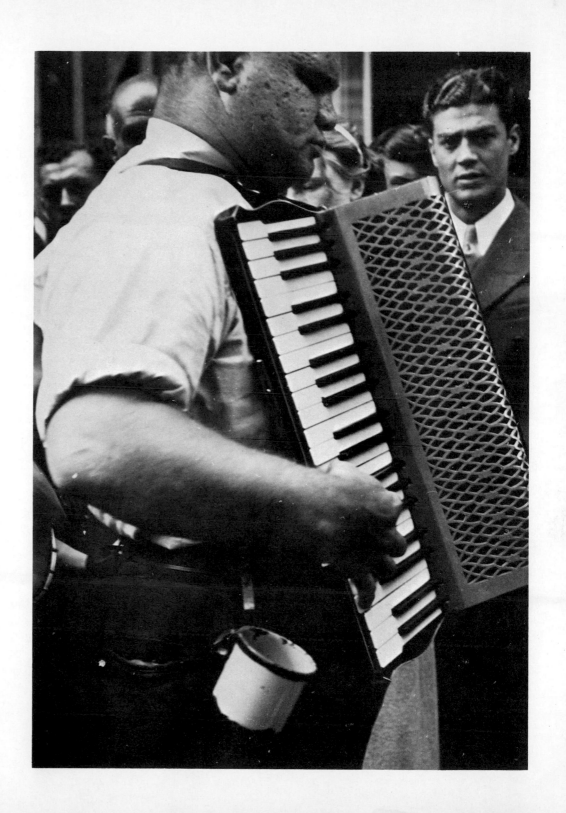

Accordion player, New York City, n.d.

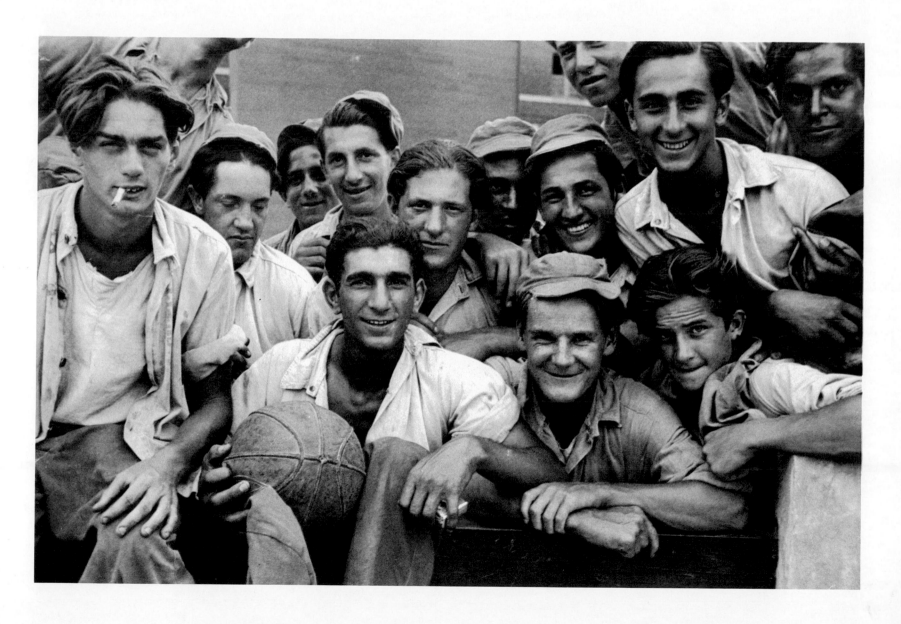

New Hampton Reformatory, New York, 1934

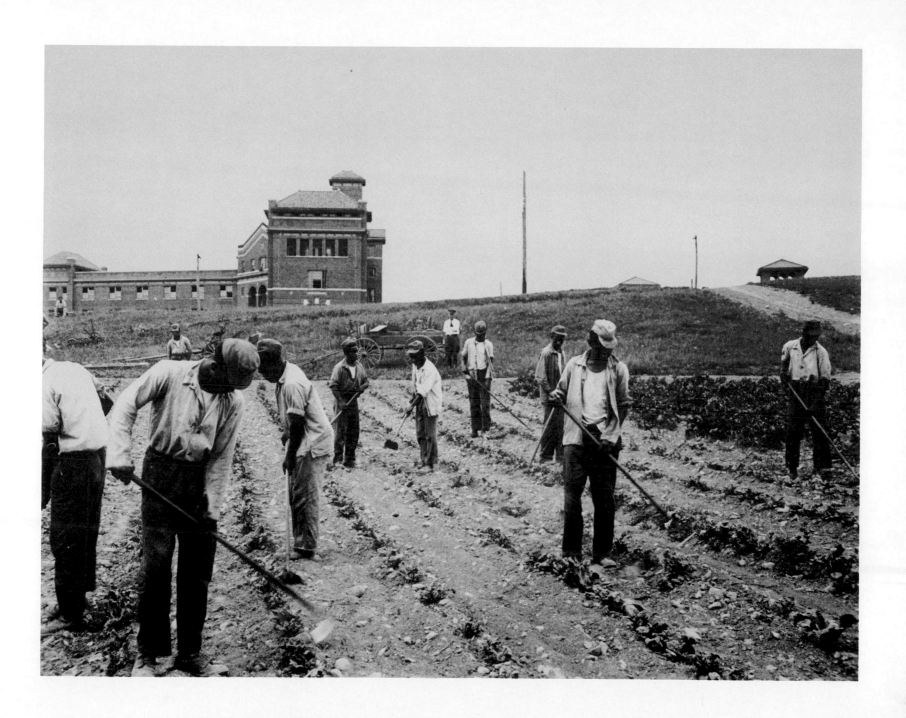

New Hampton Reformatory, New York, 1934

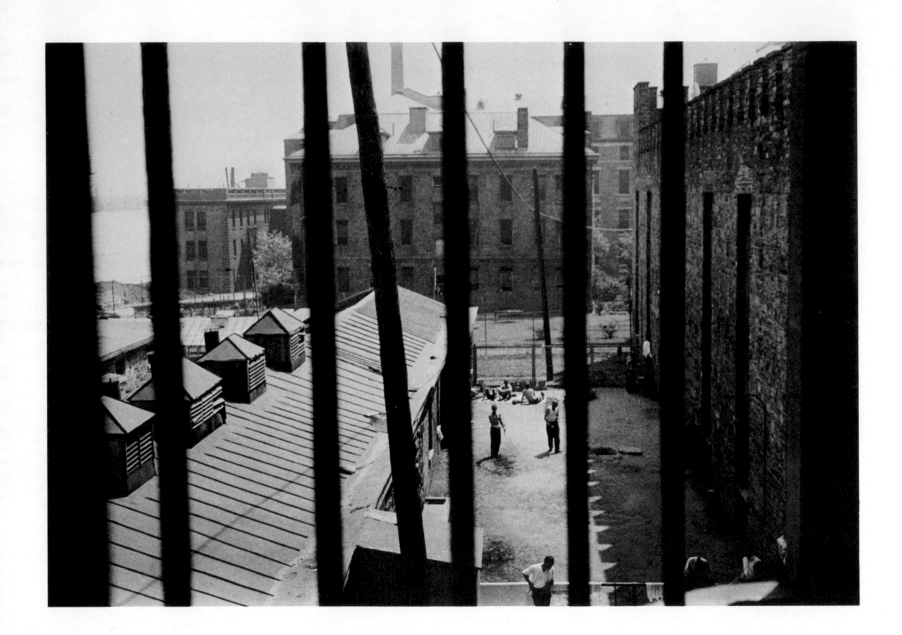

32

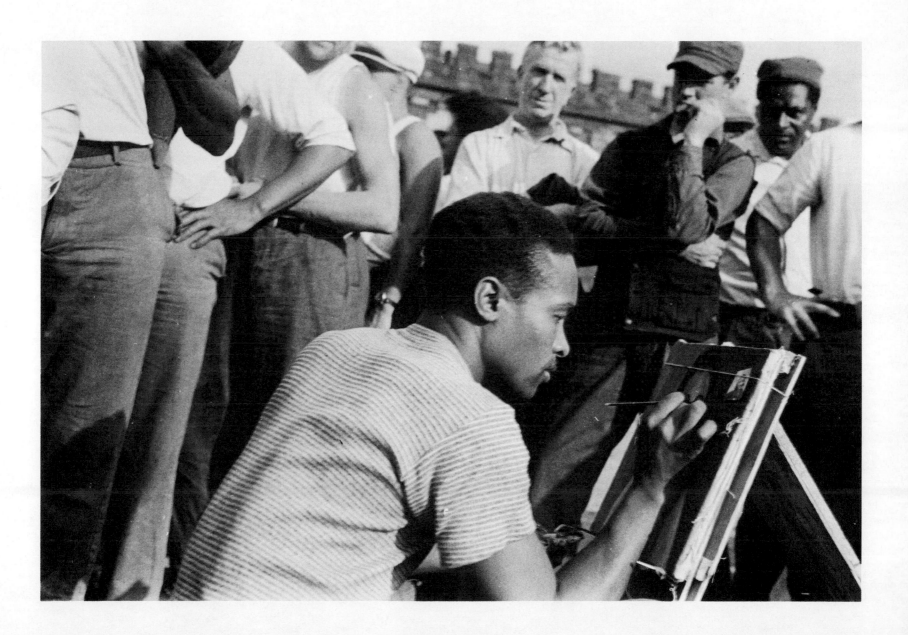

Welfare Island, New York, 1934

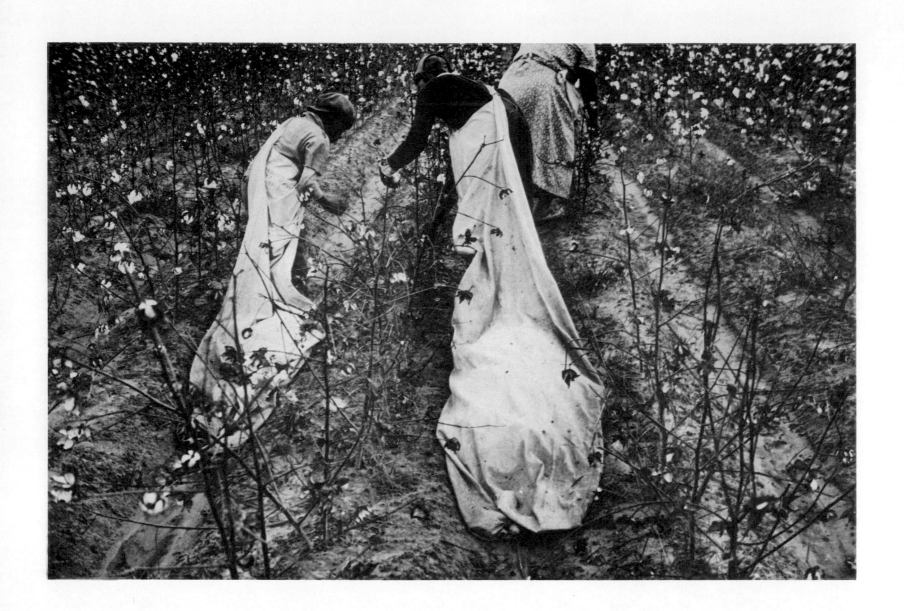

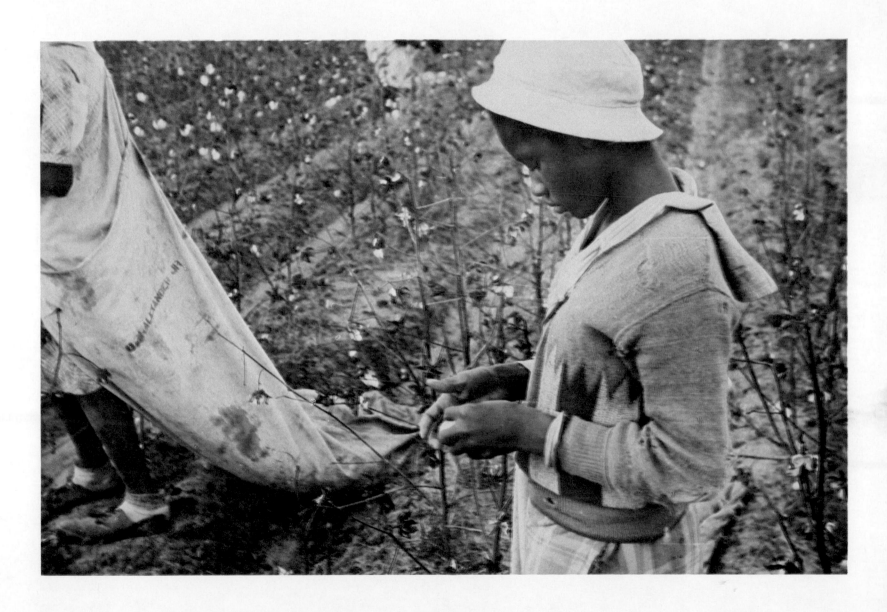

Cotton pickers, Pulaski County, Arkansas, October 1935

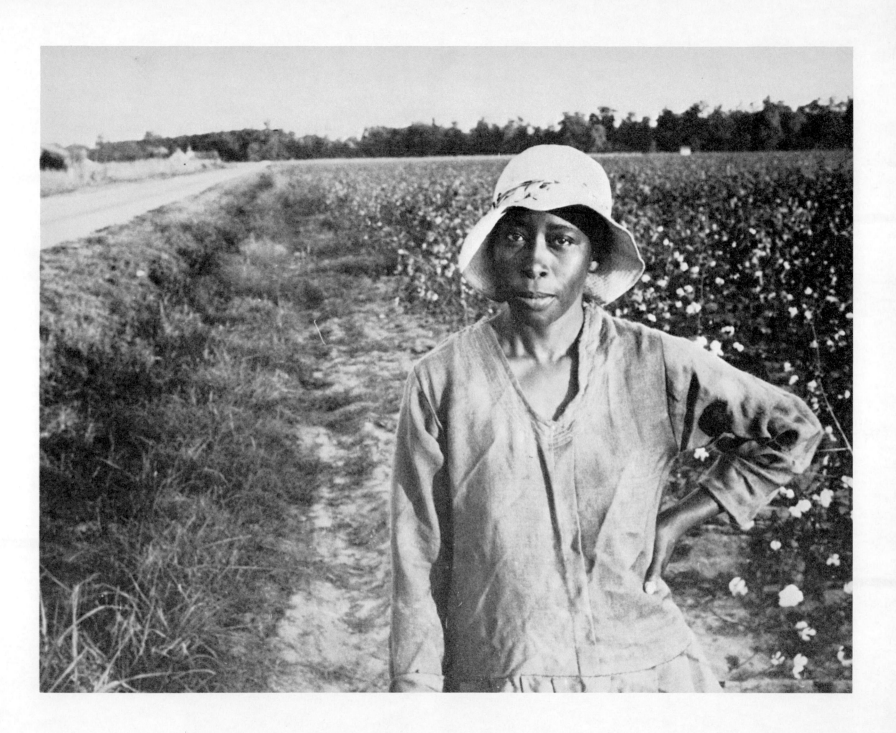

Lottie, cotton picker, Pulaski County, Arkansas, 1935

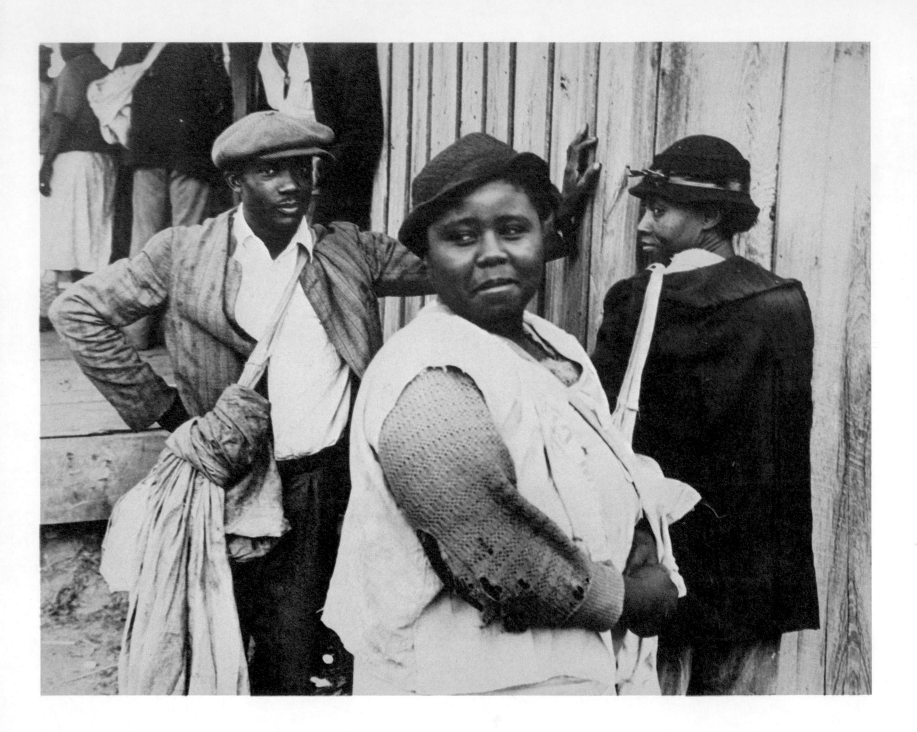

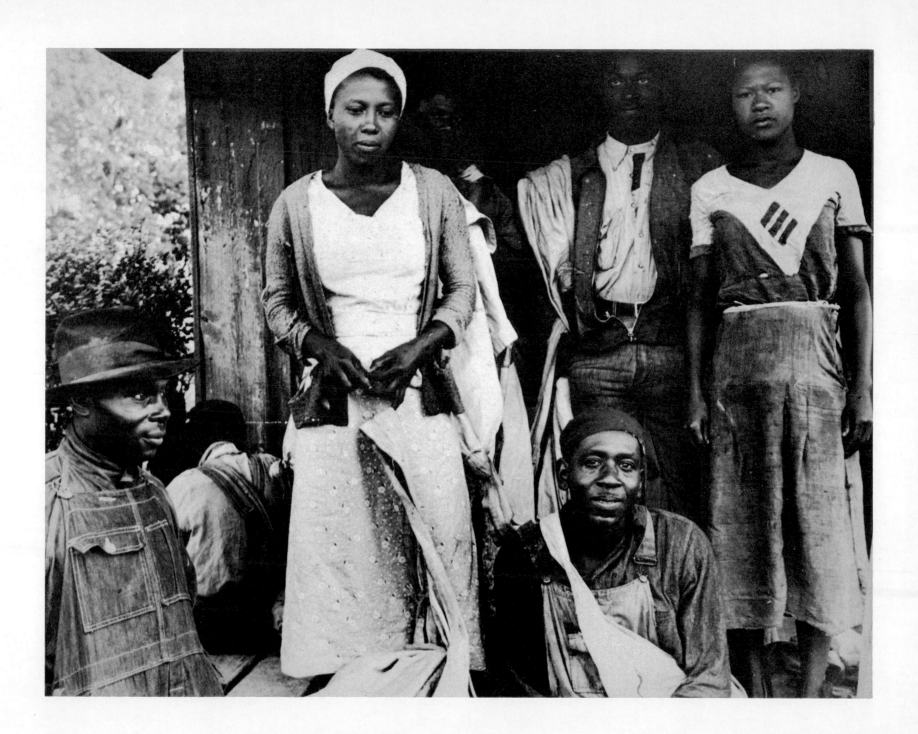

Cotton pickers, Pulaski County, Arkansas, 1935

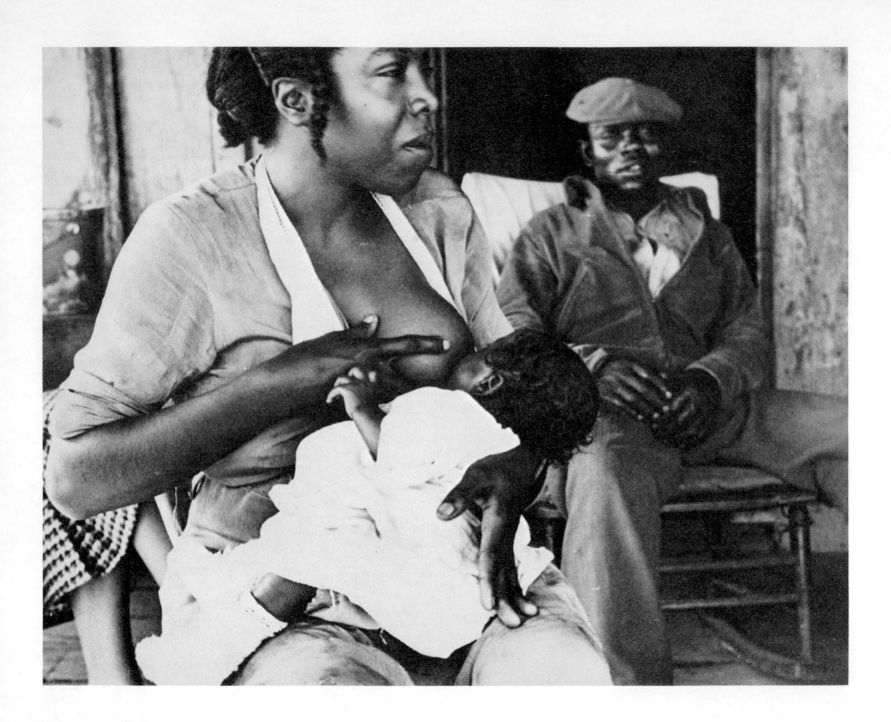

40 Sharecropper family, Little Rock, Arkansas, 1935

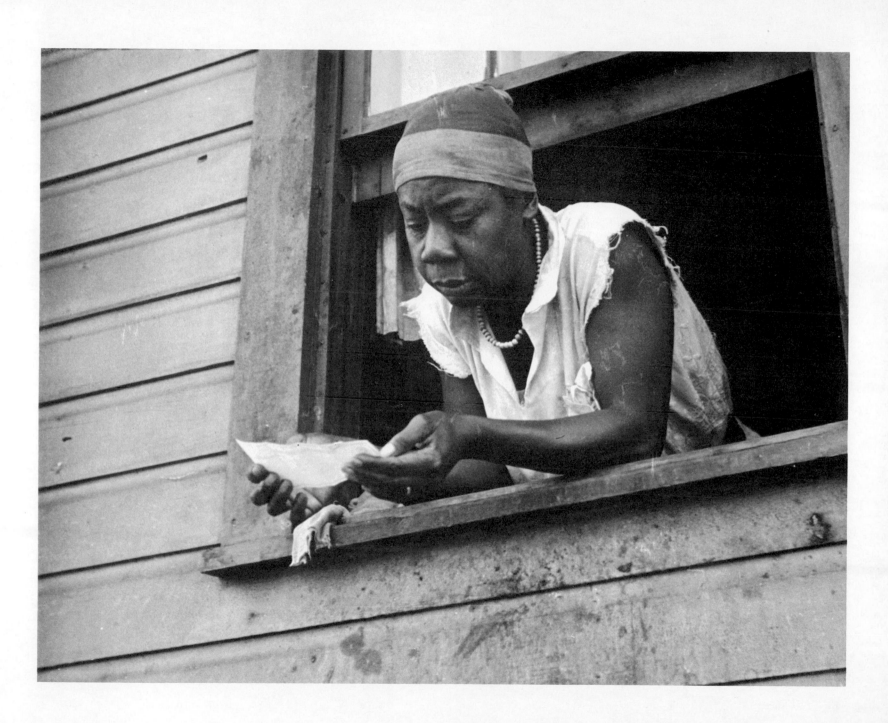

The relief check, Scott's Run, West Virginia, 1935 41

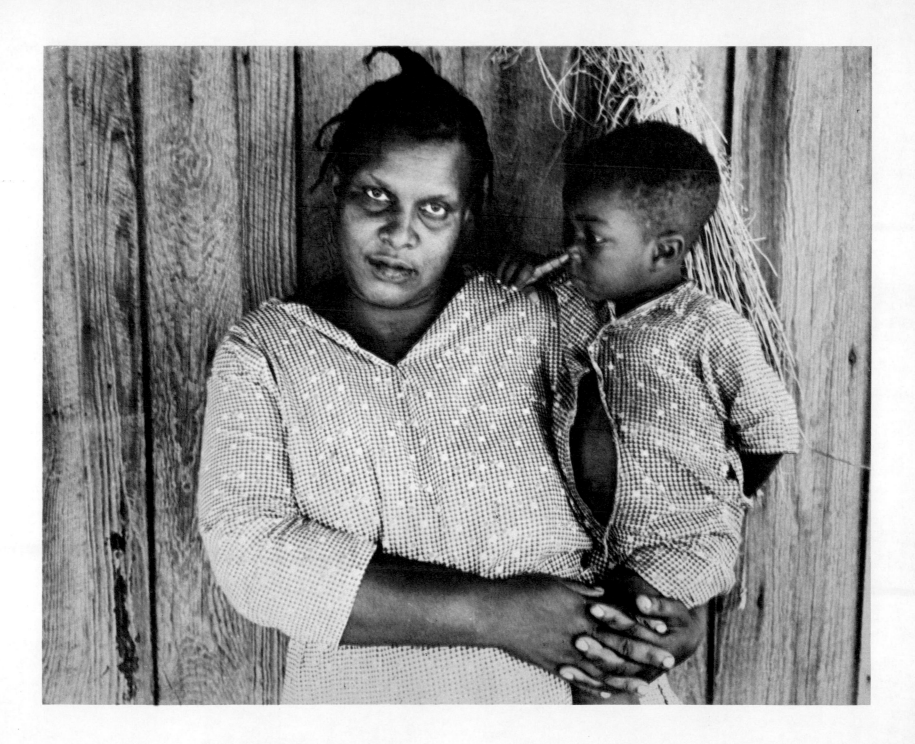

Mother and child in eastern Arkansas, 1935 43

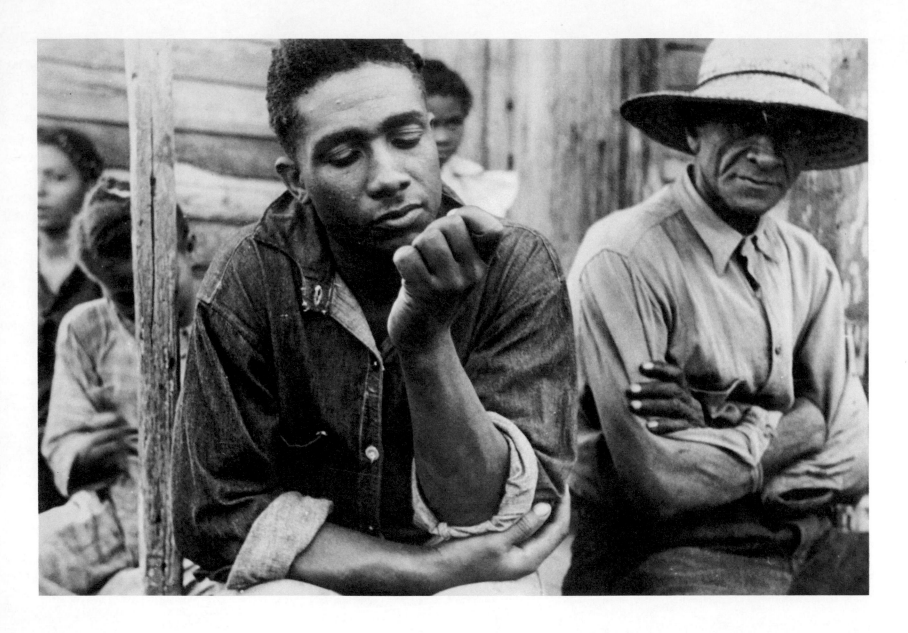

Unemployed trappers, Louisiana, 1935

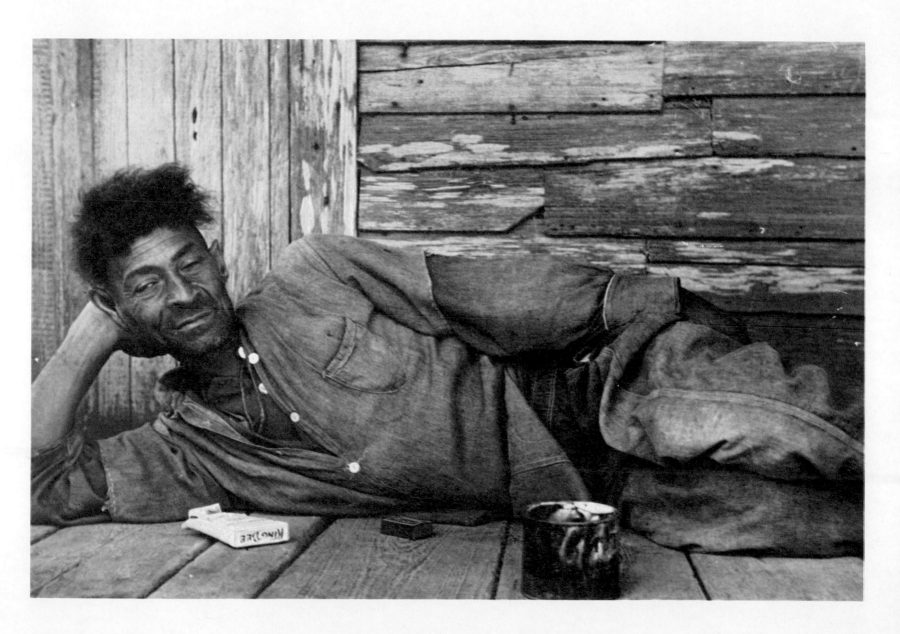

Unemployed trapper, Plaquemines Parish, Louisiana, 1935

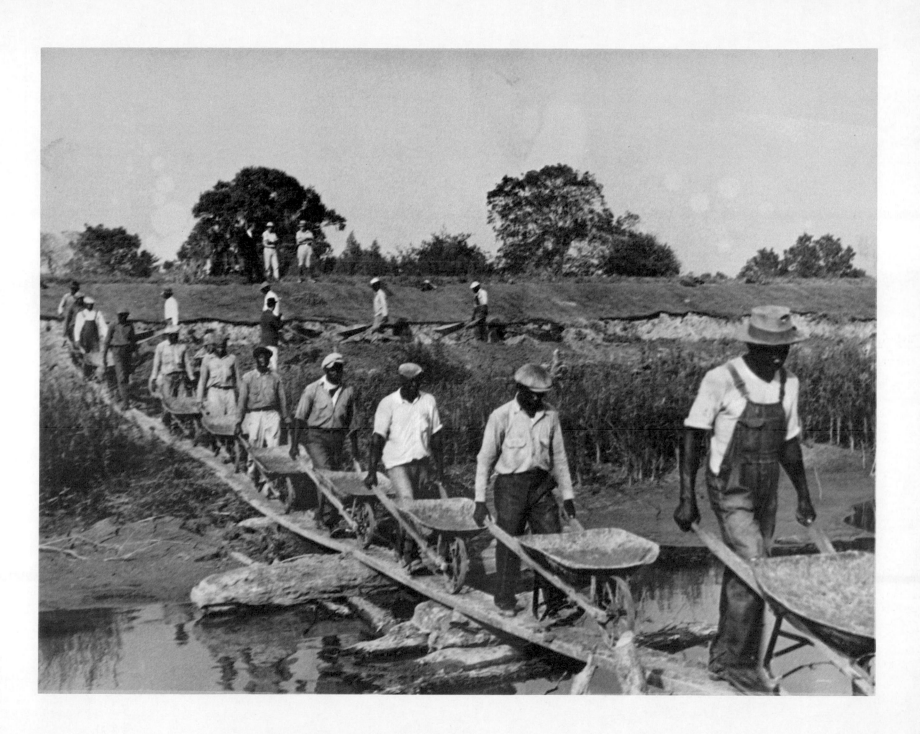

Levee workers, Plaquemines Parish, Louisiana, 1935

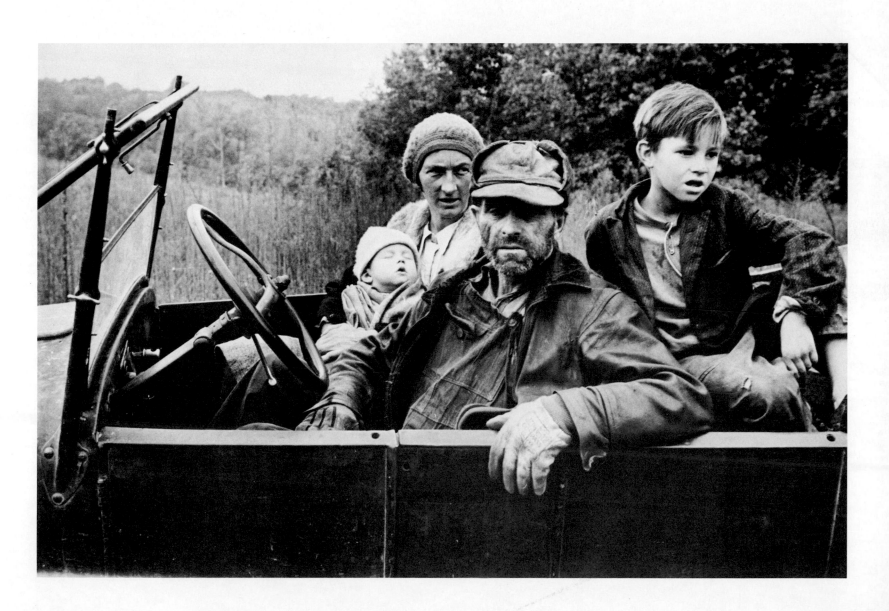

The Terwilligers, Ozark family, Arkansas, 1935

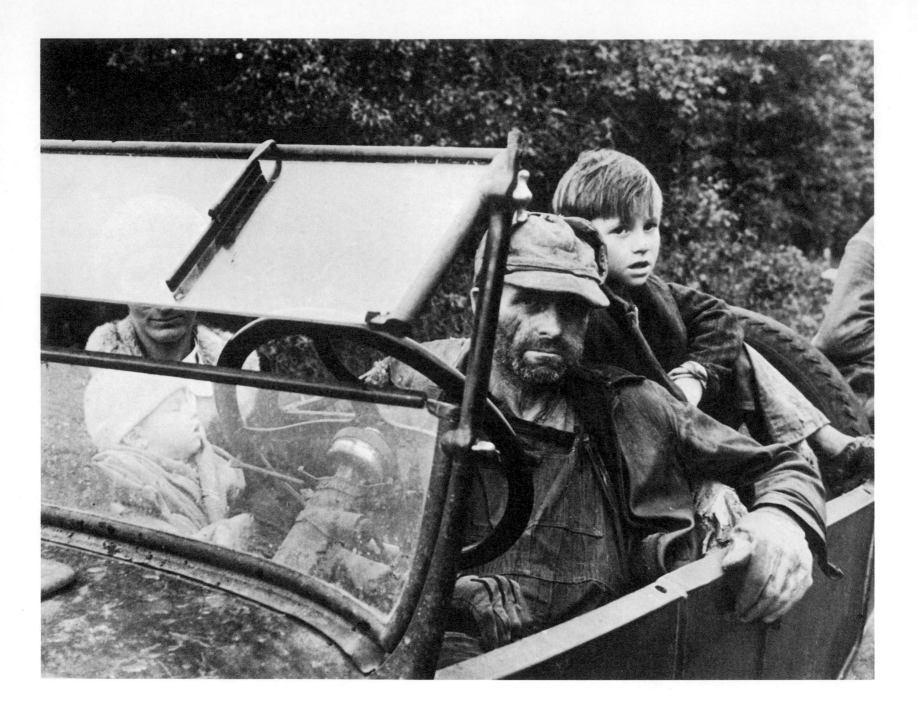

50 The Terwilligers, Ozark family, Arkansas, 1935

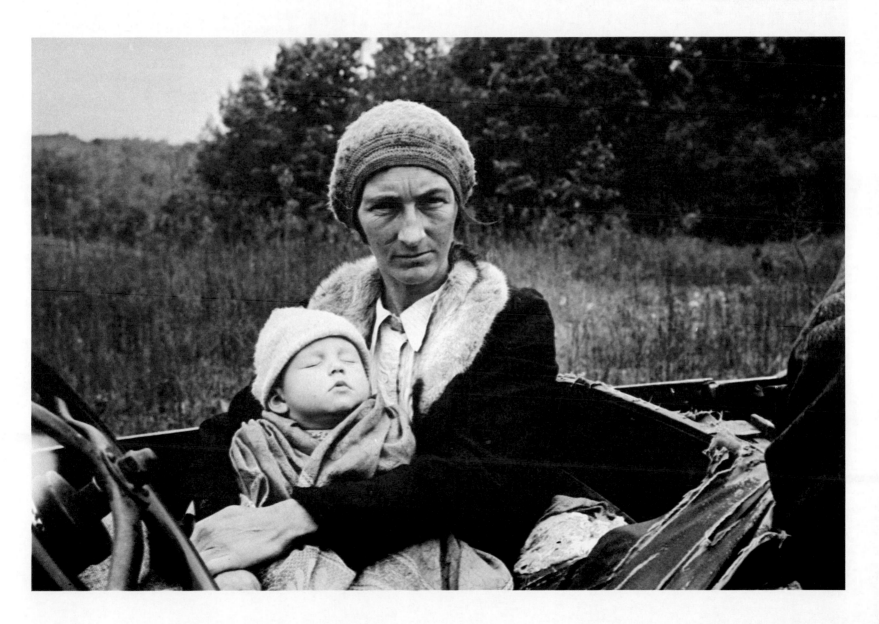

Mrs. Terwilliger and child, Arkansas, 1935

51

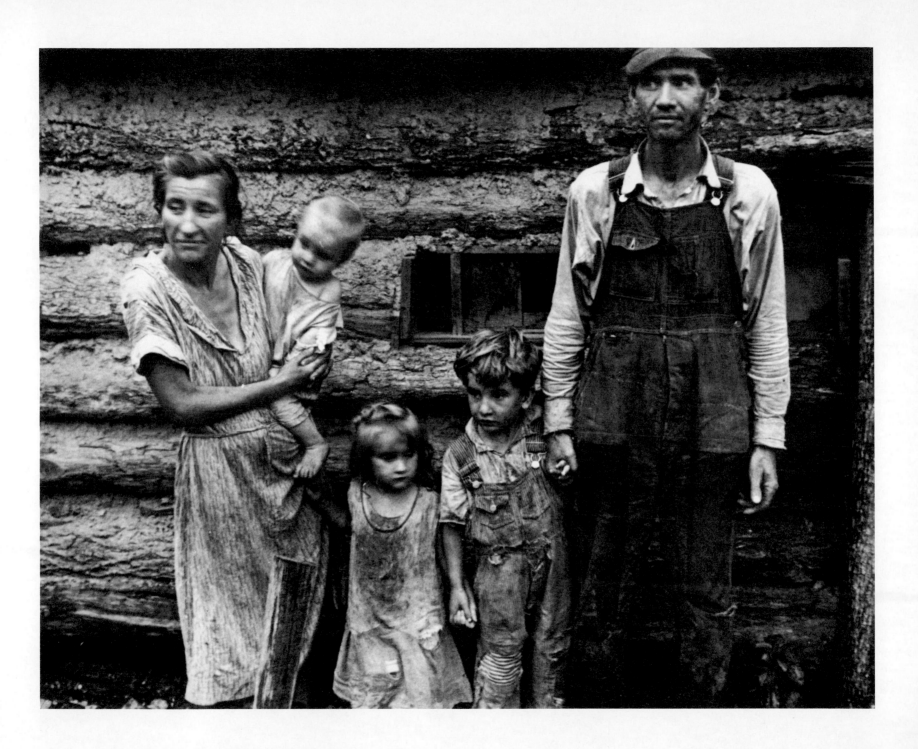

The Mulhalls, Ozark family, Arkansas, 1935

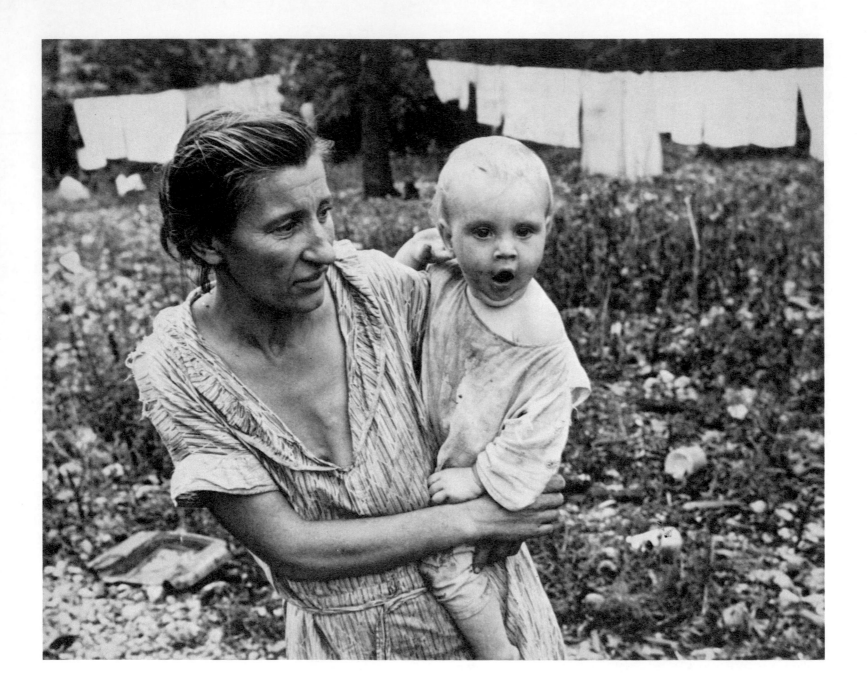

54

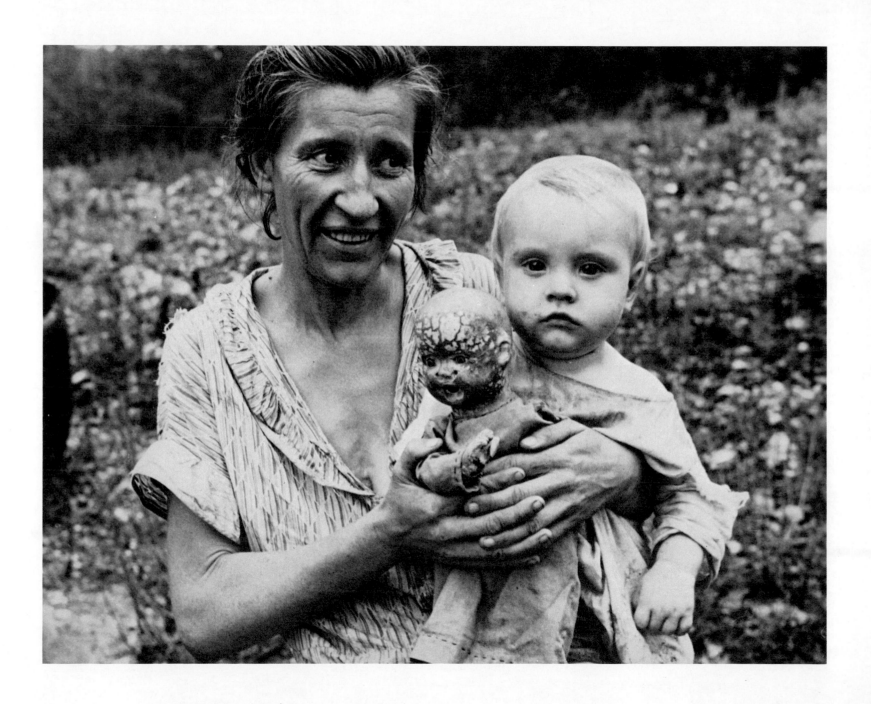

Mrs. Mulhall and child, Ozark family, Arkansas, 1935

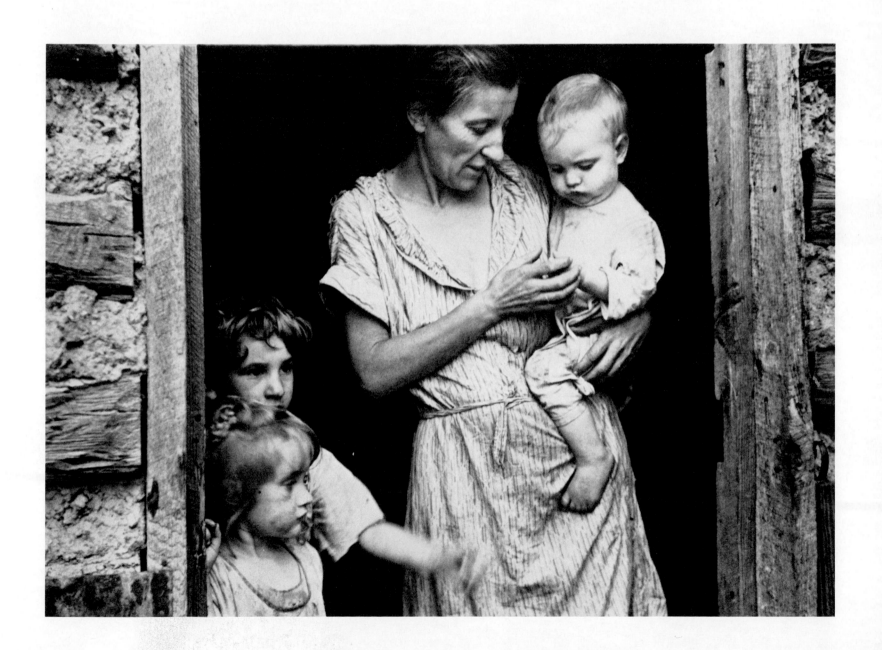

Mrs. Mulhall and children, Ozark family, Arkansas, 1935 57

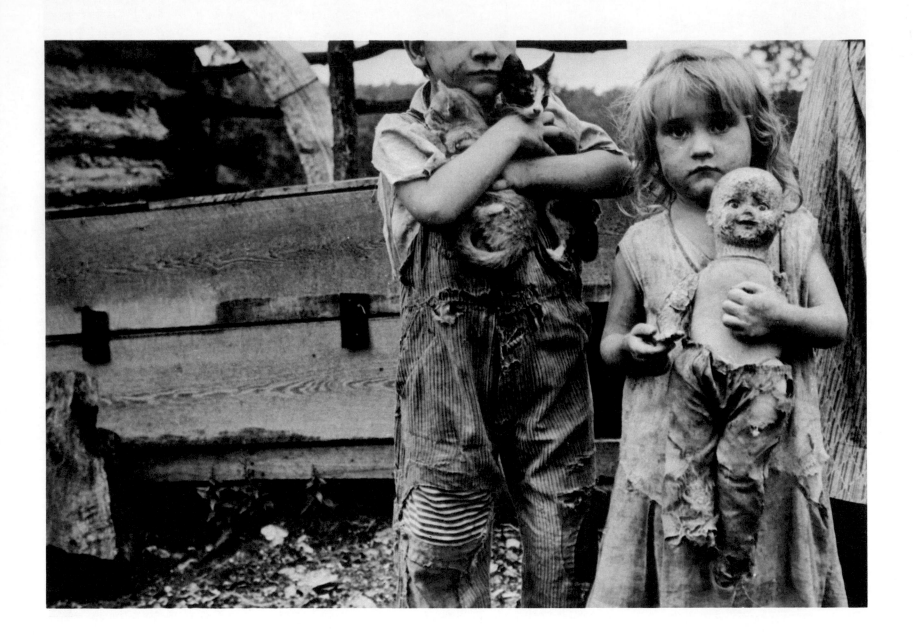

58

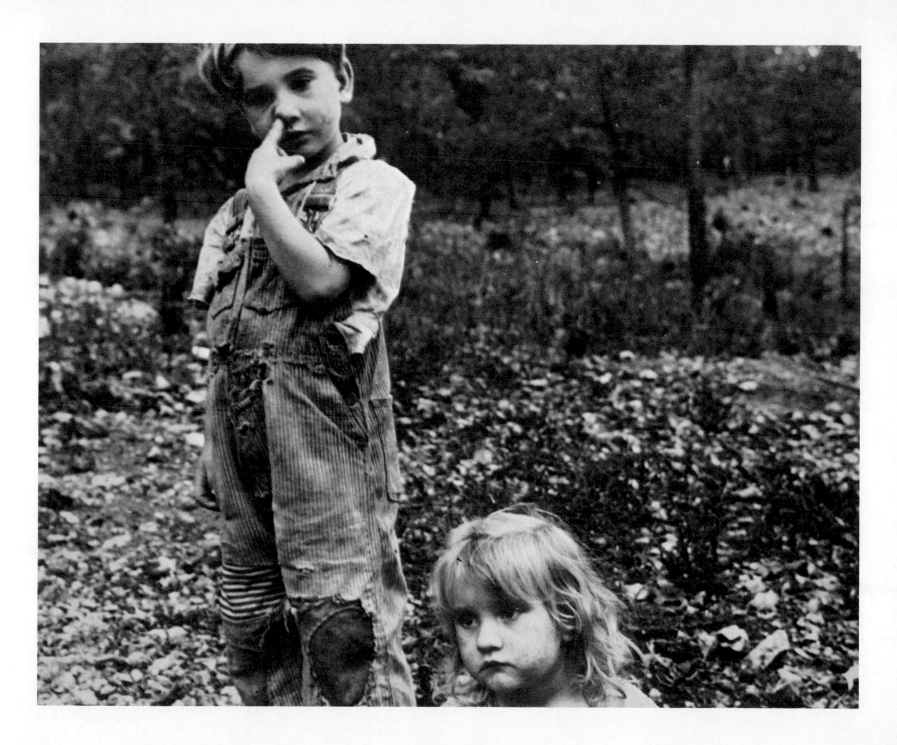

Mulhall children, Ozark mountaineer family, Arkansas, 1935

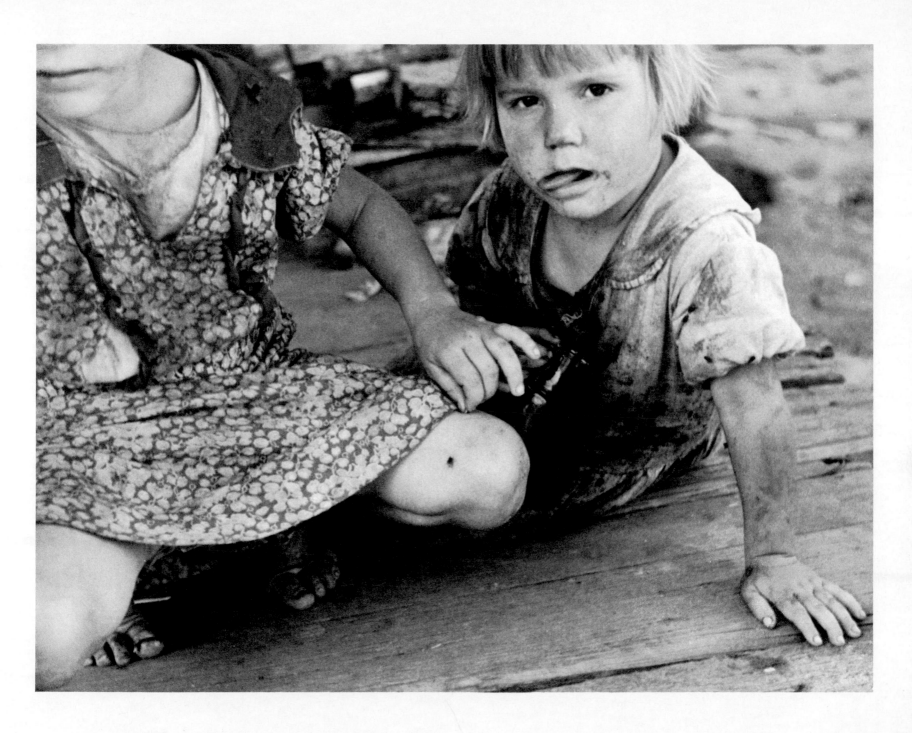

Children of Ozark mountaineer, Arkansas, 1935

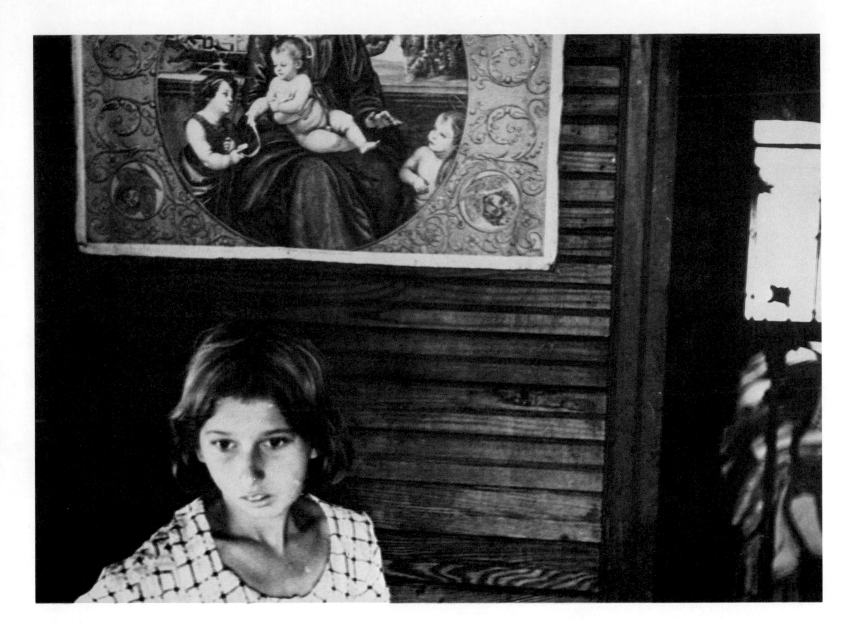

Child of Fortuna family, Hammond, Louisiana, 1935

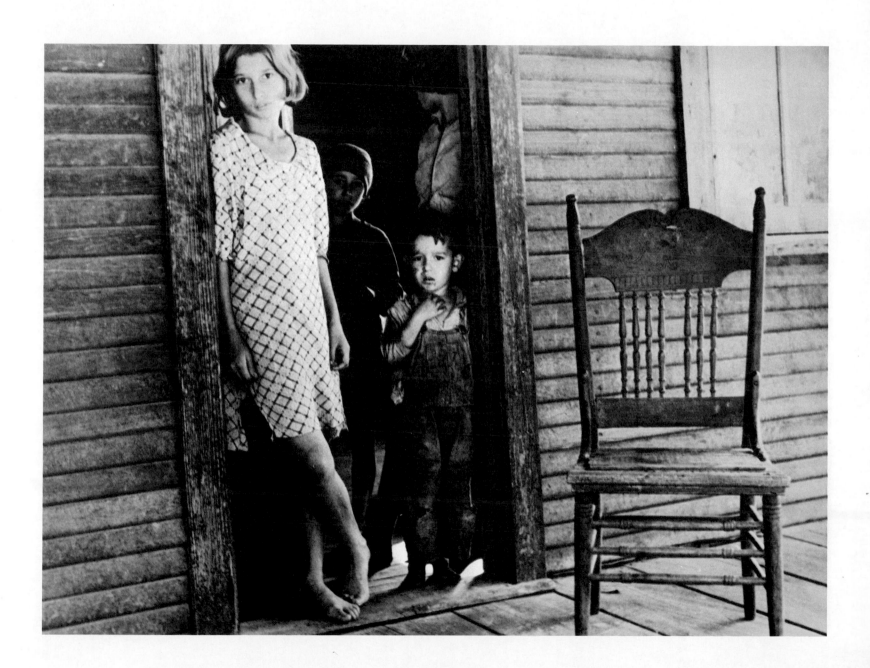

Children of Fortuna family, Hammond, Louisiana, 1935

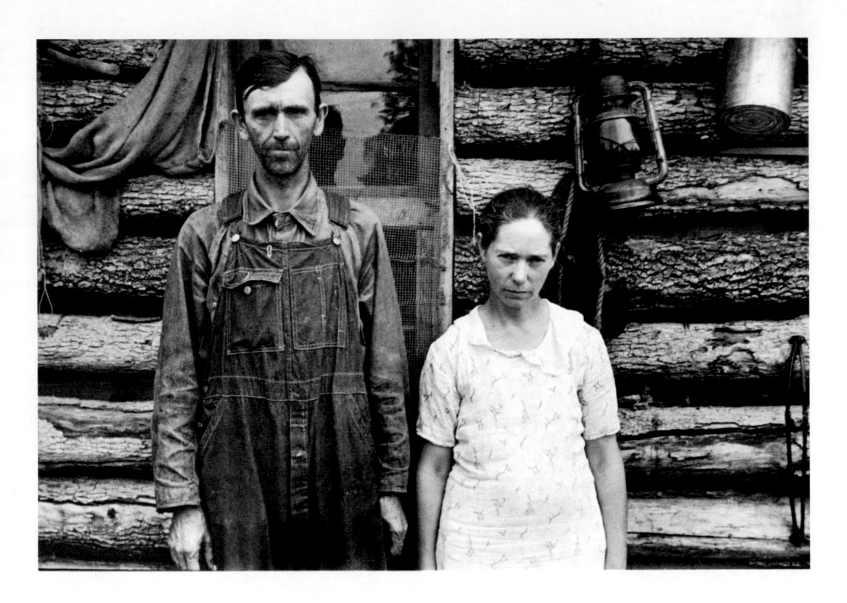

Rehabilitation clients, Boone County, Arkansas, 1935

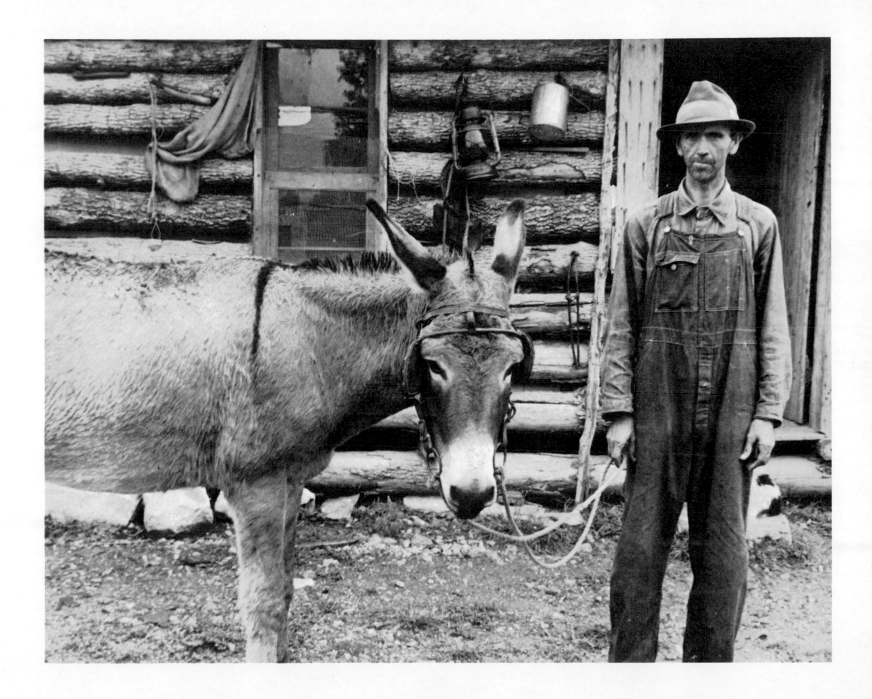

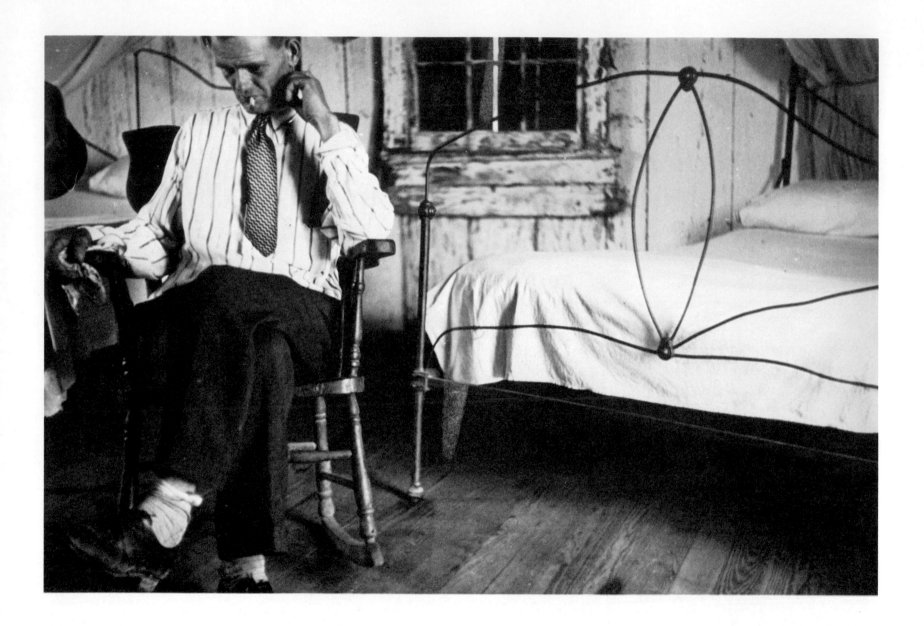

Father of Trische family, Plaquemines Parish, Louisiana, 1935

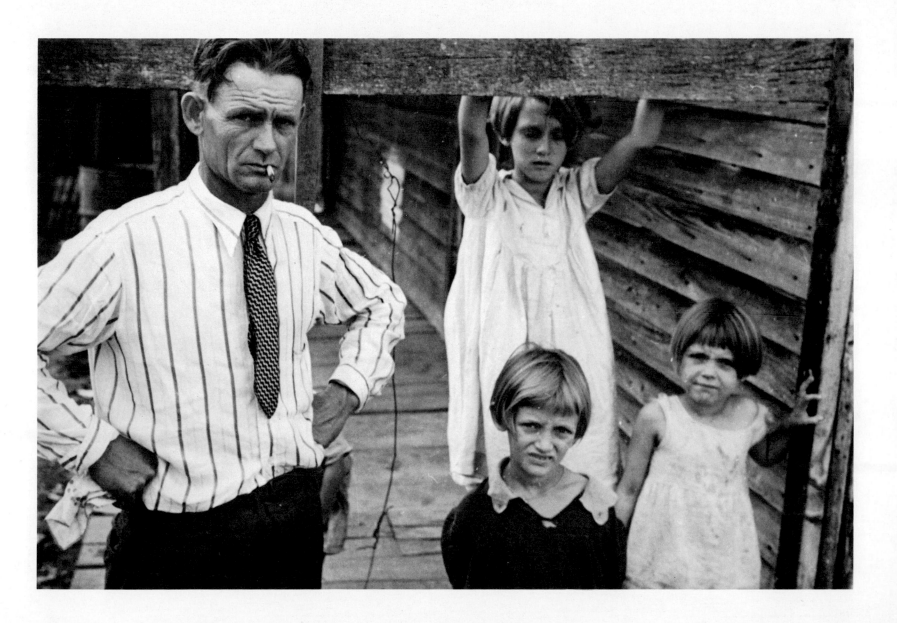

Trische family, tenant farmers, Plaquemines Parish, Louisiana, 1935

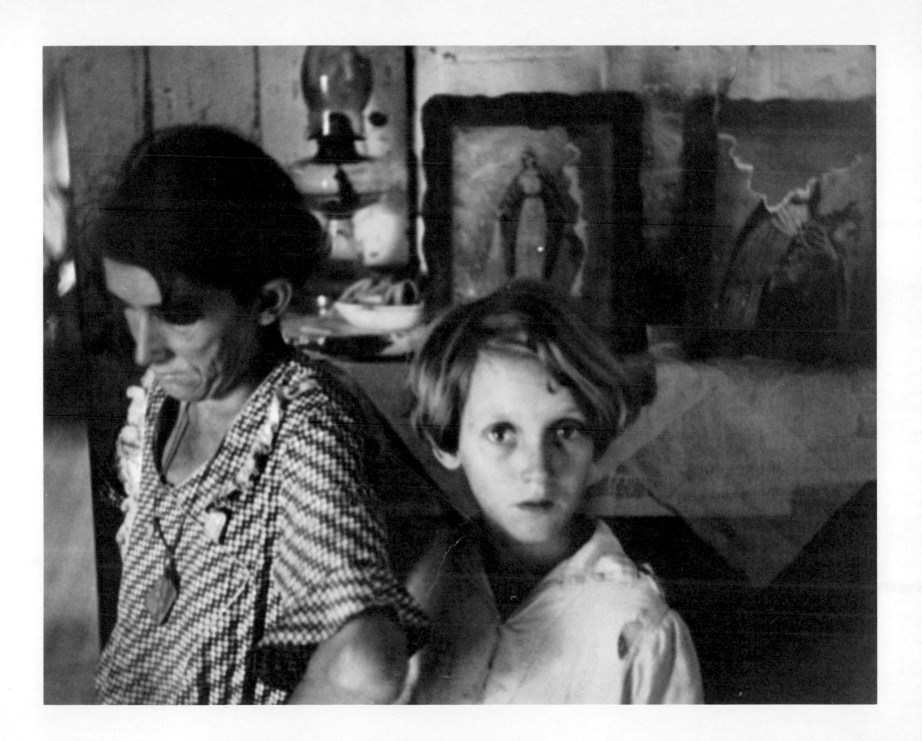

Mrs. Trische and daughter, Plaquemines Parish, Louisiana, 1935

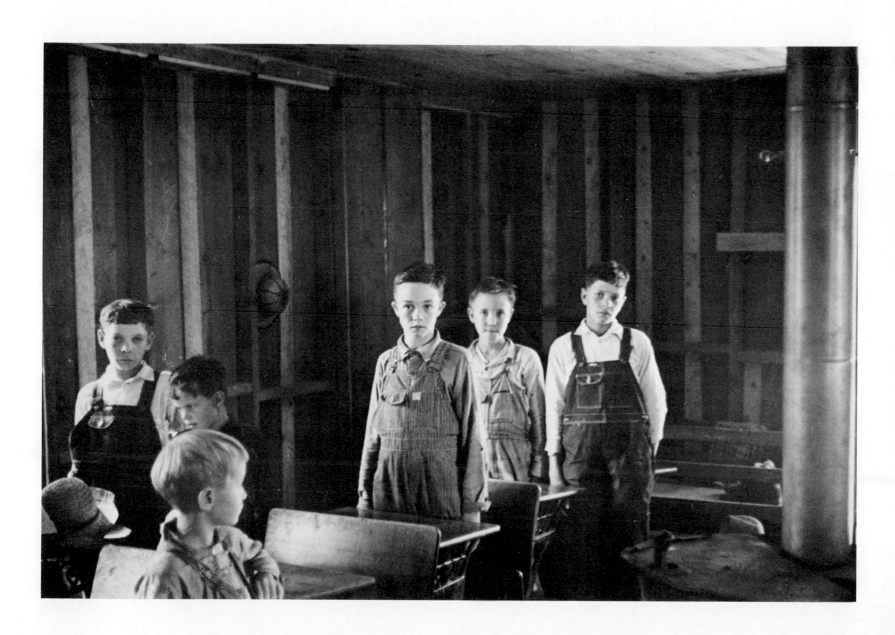

Interior of Ozark school, Arkansas, 1935

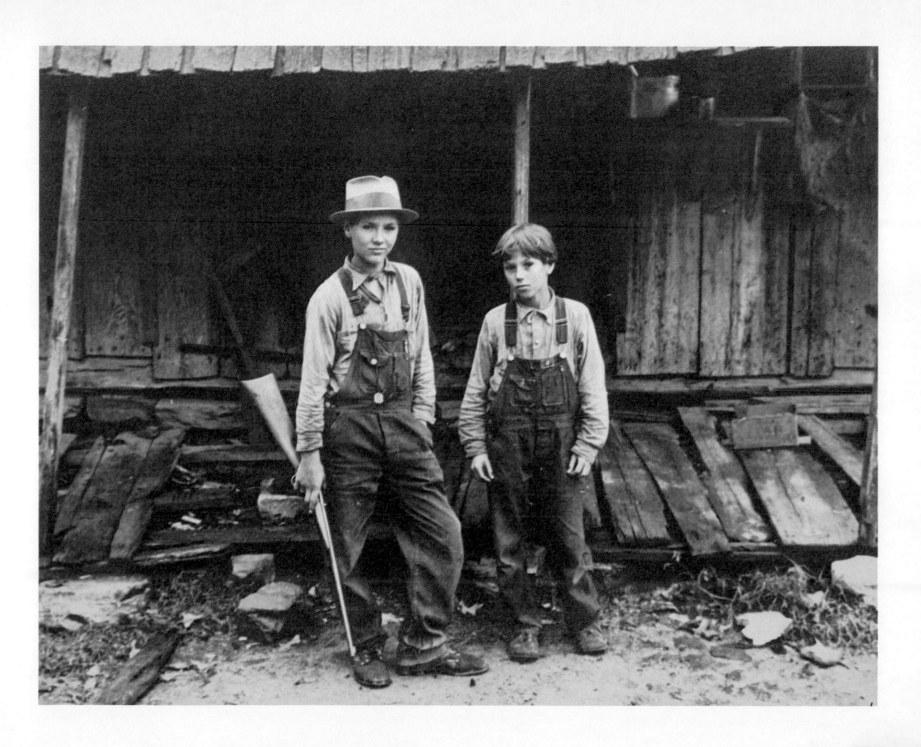

Children of Mitchell family, Arkansas, 1935

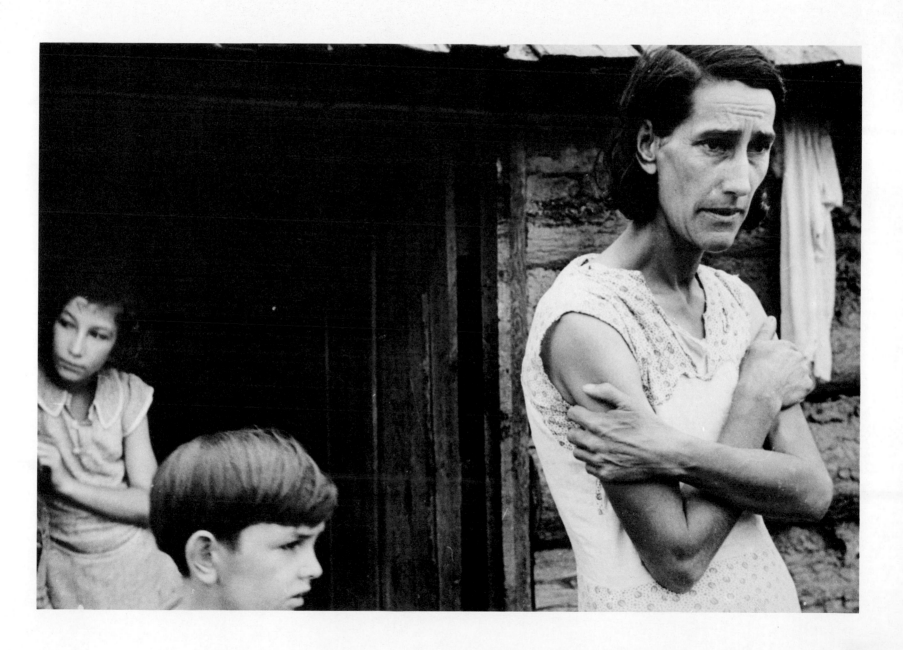

Rehabilitation client, Boone County, Arkansas, 1935 75

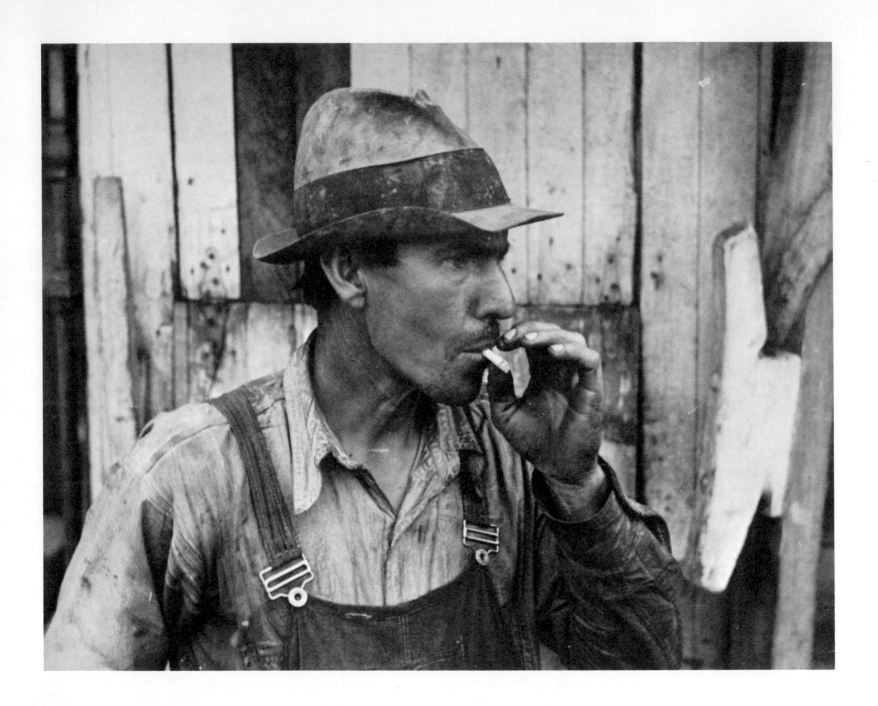

76 Deckhand aboard the *Queen of Dycusburg*, Memphis, Tennessee, 1935

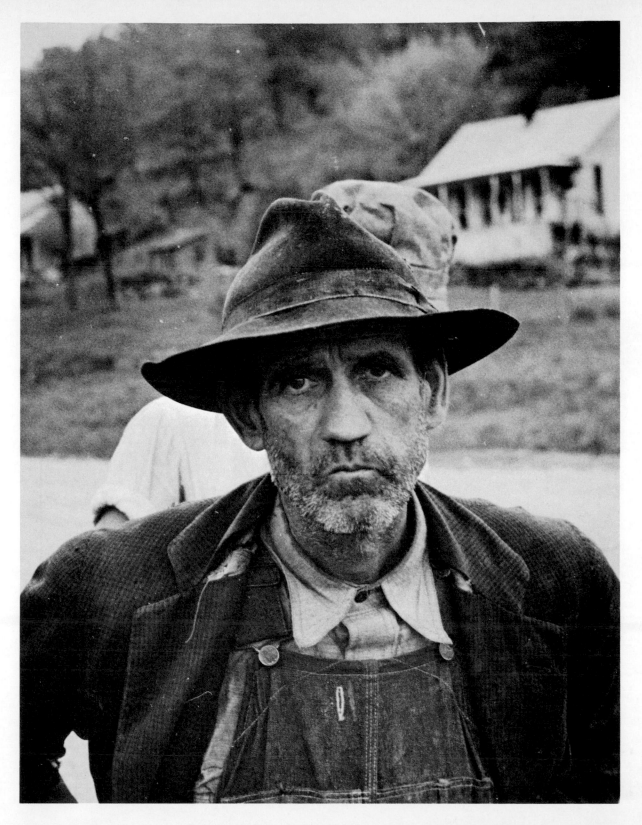

Citizen of Zinc, Arkansas, deserted mining town, 1935

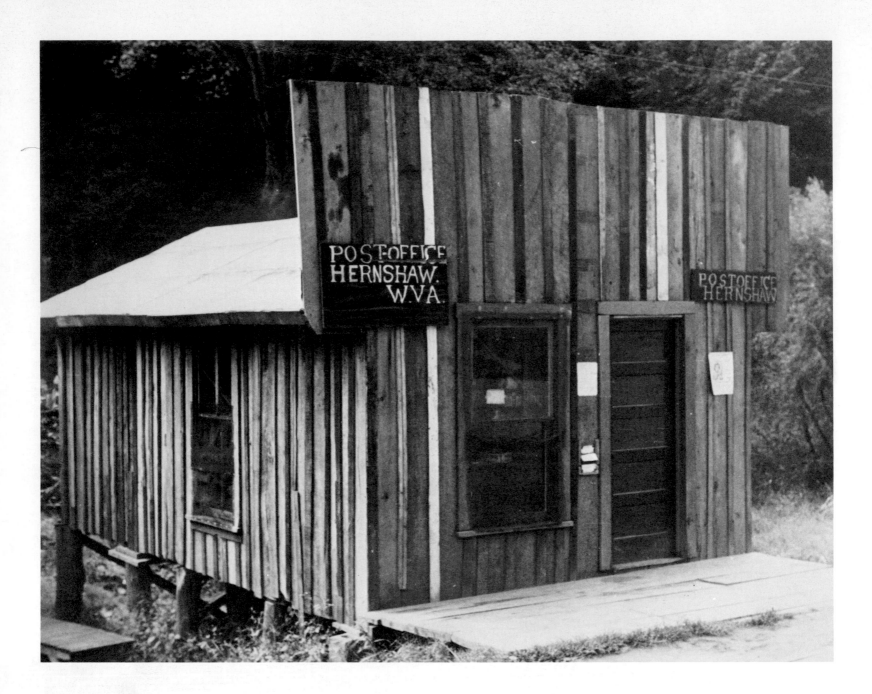

78 Post office, Hernshaw, West Virginia, 1935

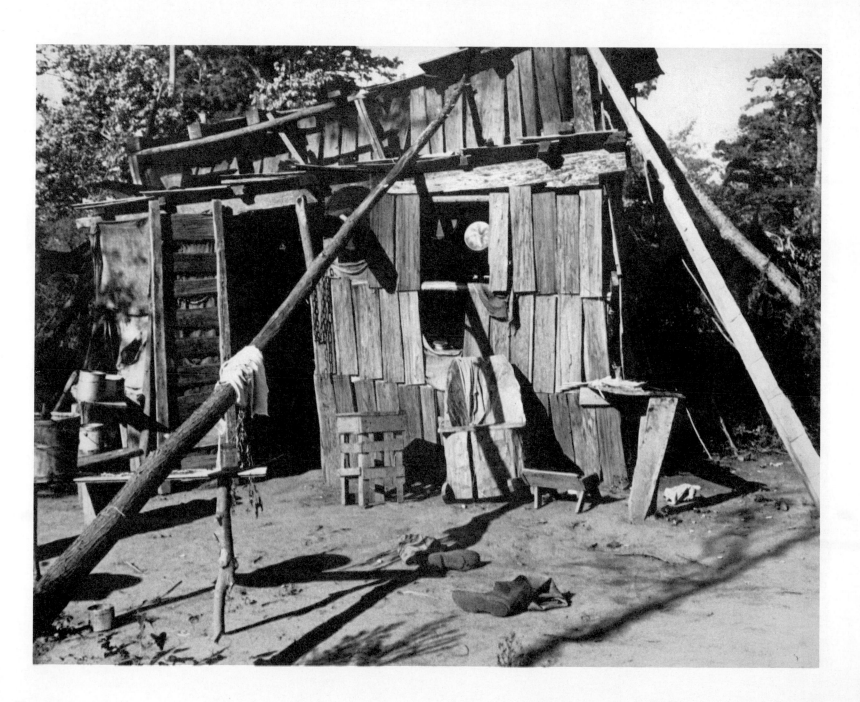

Arkansas squatter's home, 1935 79

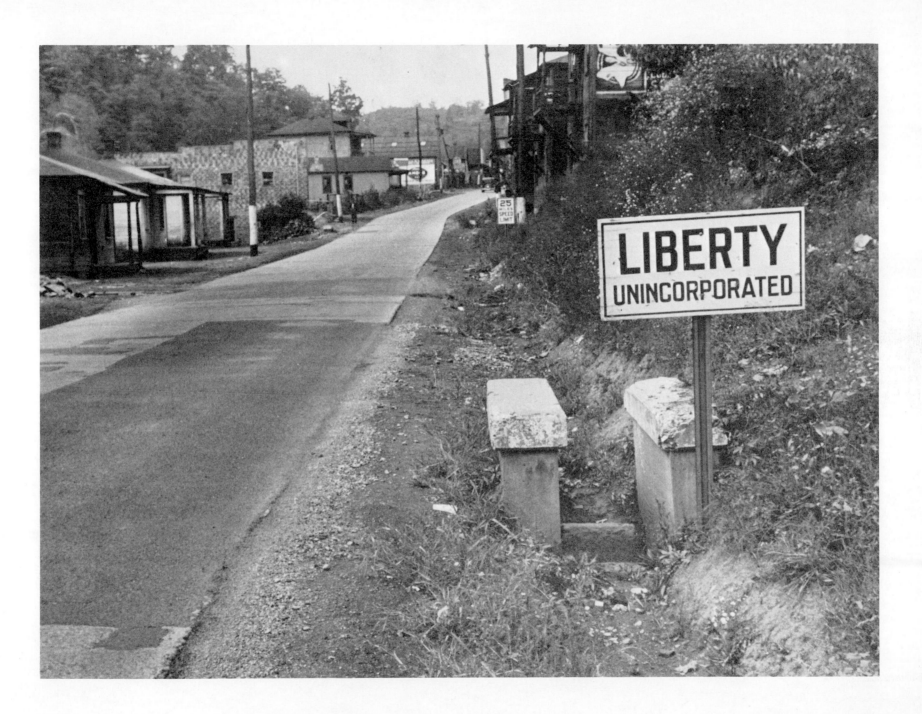

Liberty Unincorporated, West Virginia, 1935

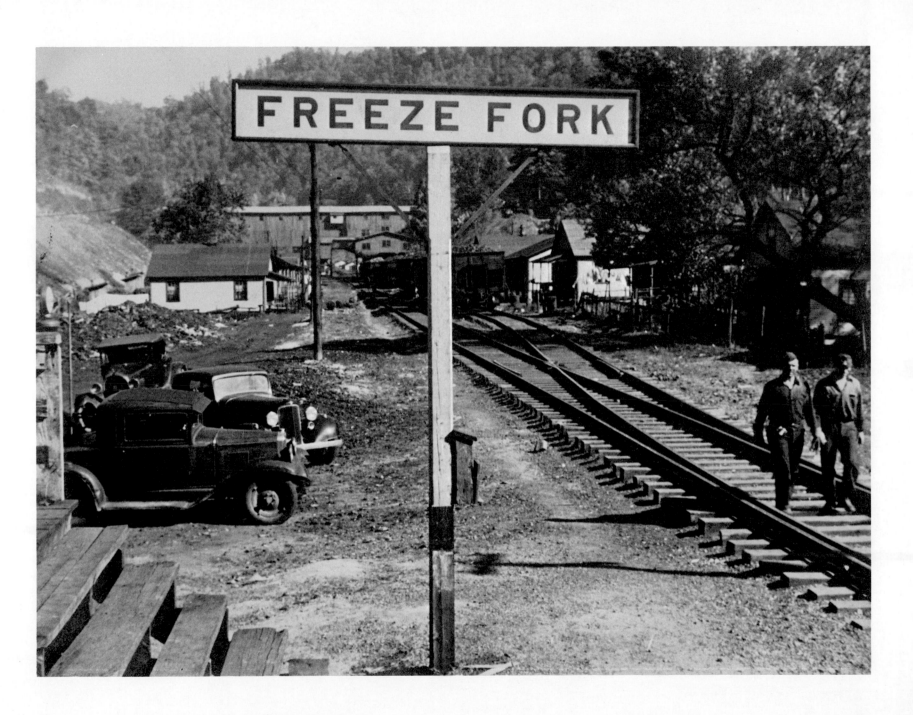

Freeze Fork, West Virginia, 1935

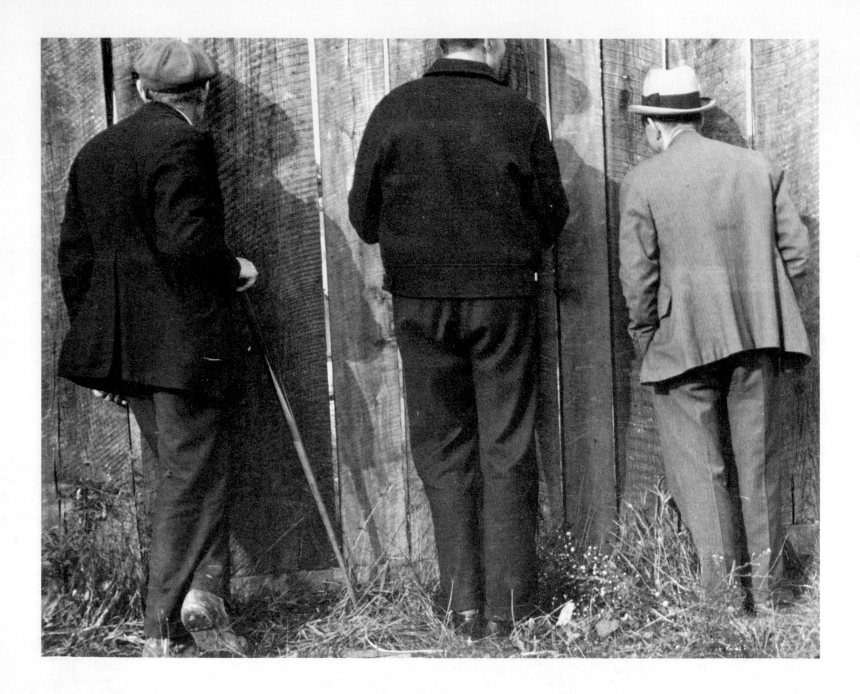

Sunday football game, Scott's Run, West Virginia, 1935

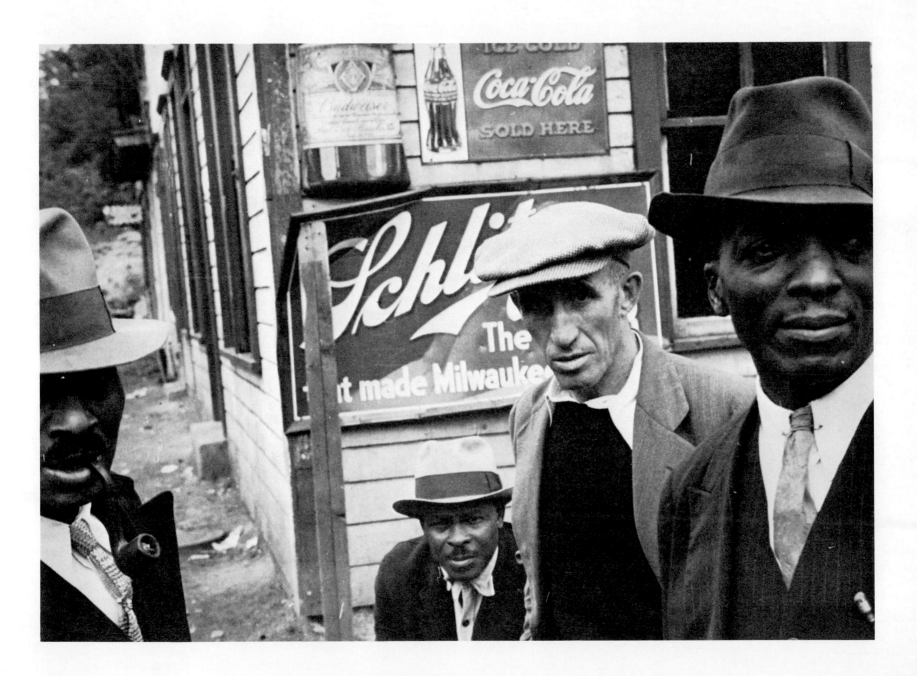

Sunday, Scott's Run, West Virginia, 1935

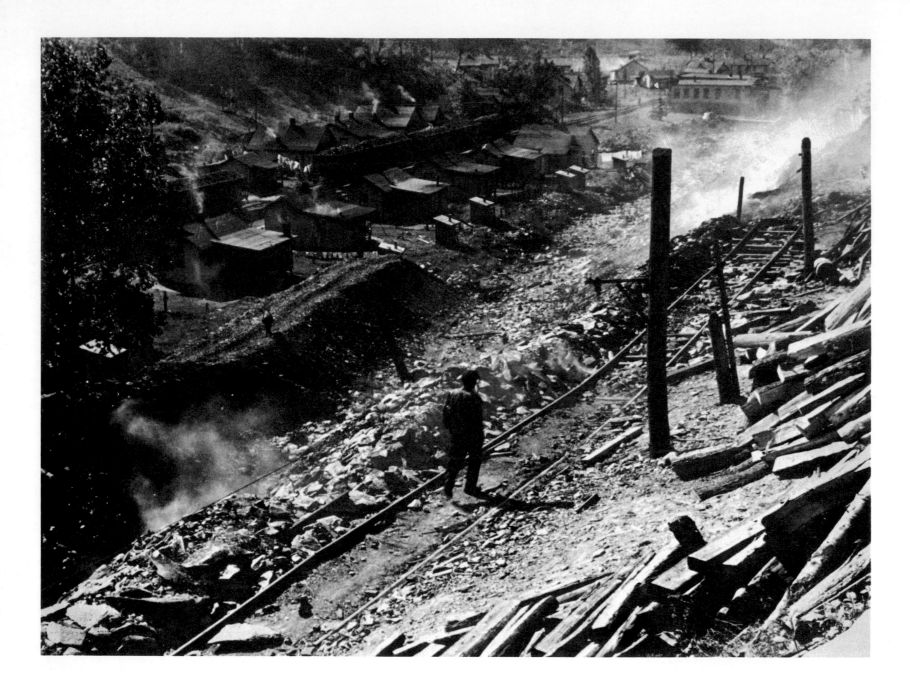

86

View of Freeze Fork, West Virginia, 1935

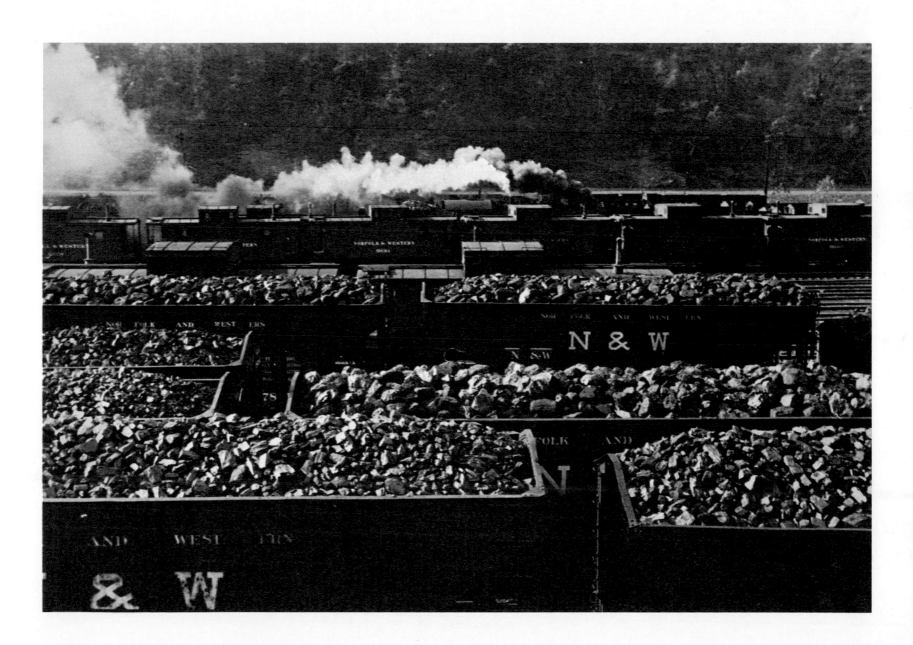

Williamson, West Virginia, 1935

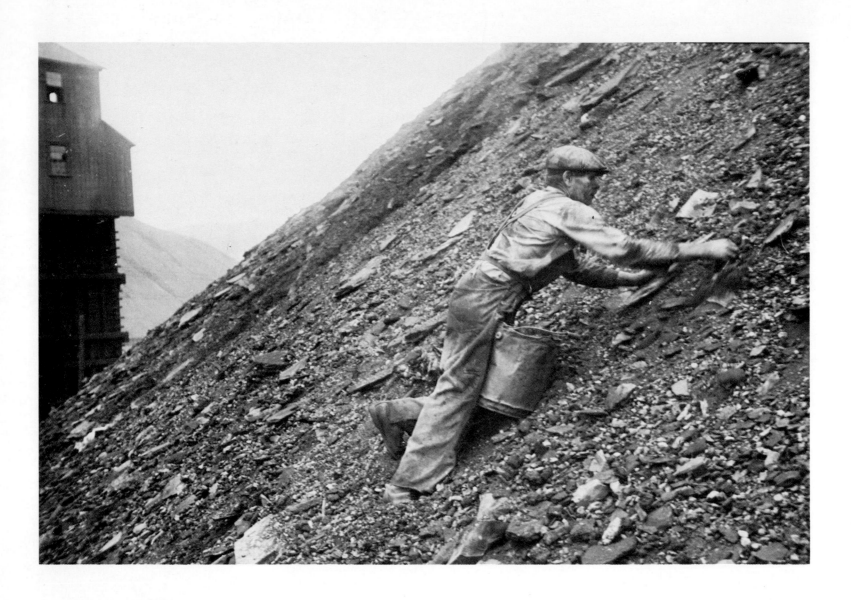

Man collecting coal from slag heap, Nanty Glo, Pennsylvania, 1937

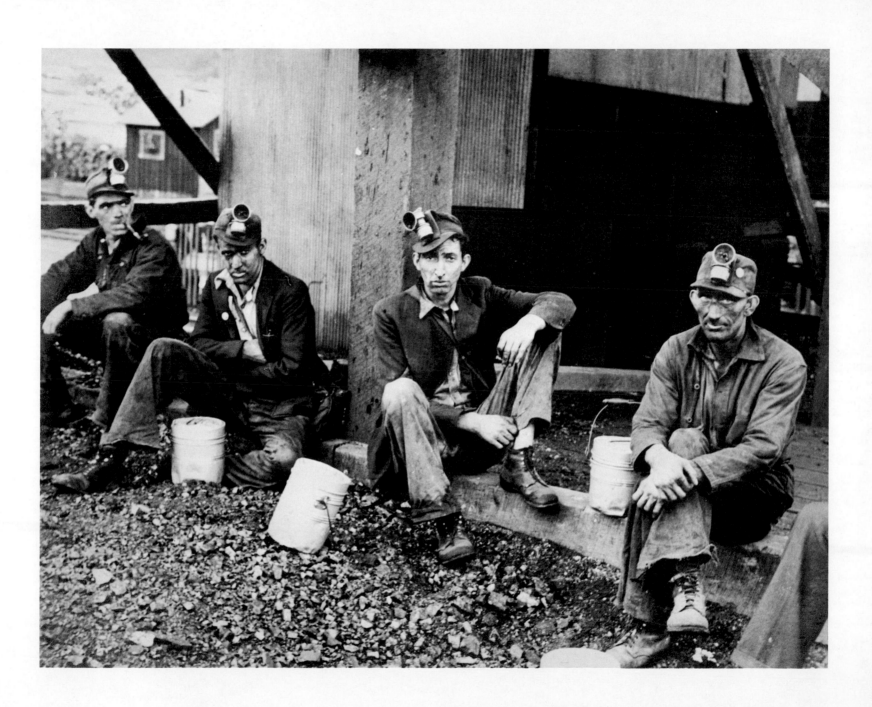

Coal miners, Williamson, West Virginia, 1935 89

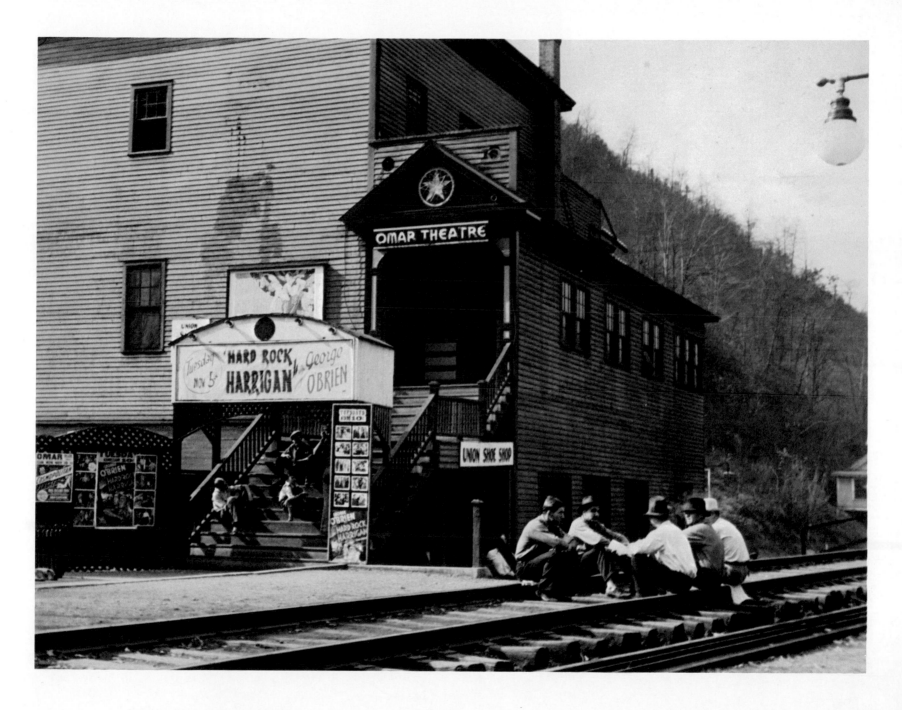

Omar, West Virginia, 1935

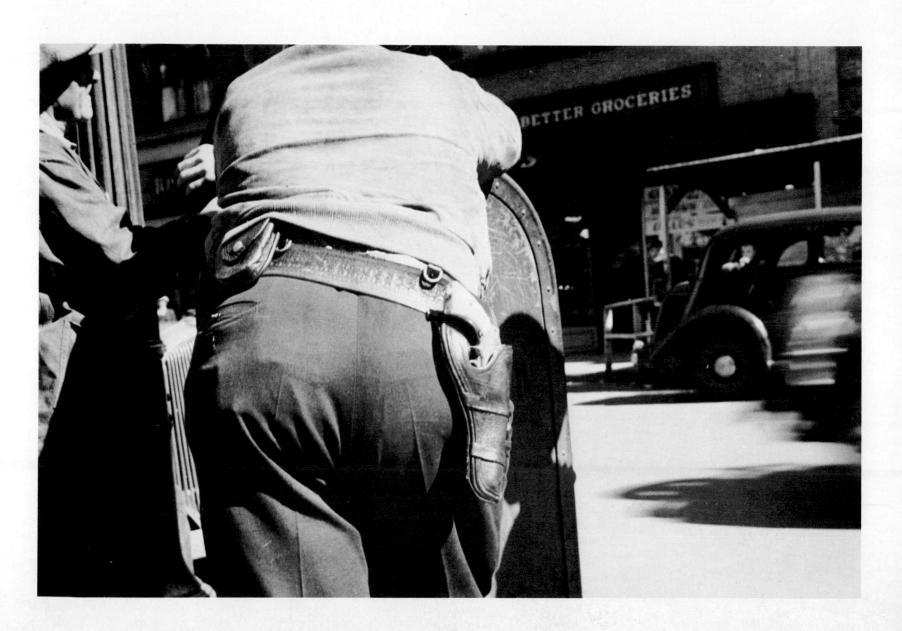

Sheriff during strike, Morgantown, West Virginia, 1935

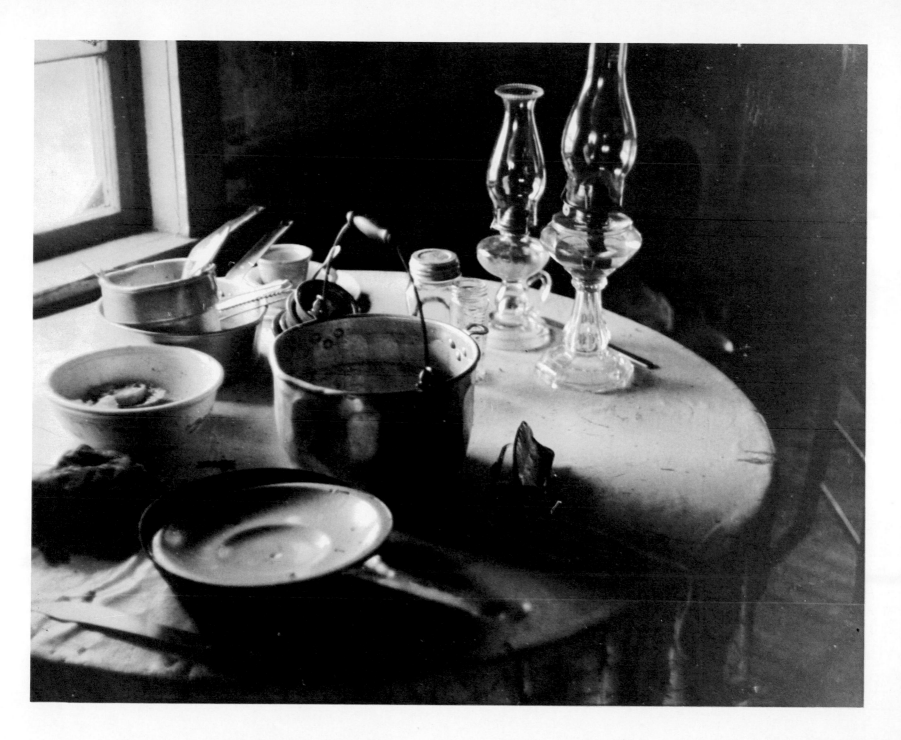

Kitchen table, Calumet, Pennsylvania, 1935

95

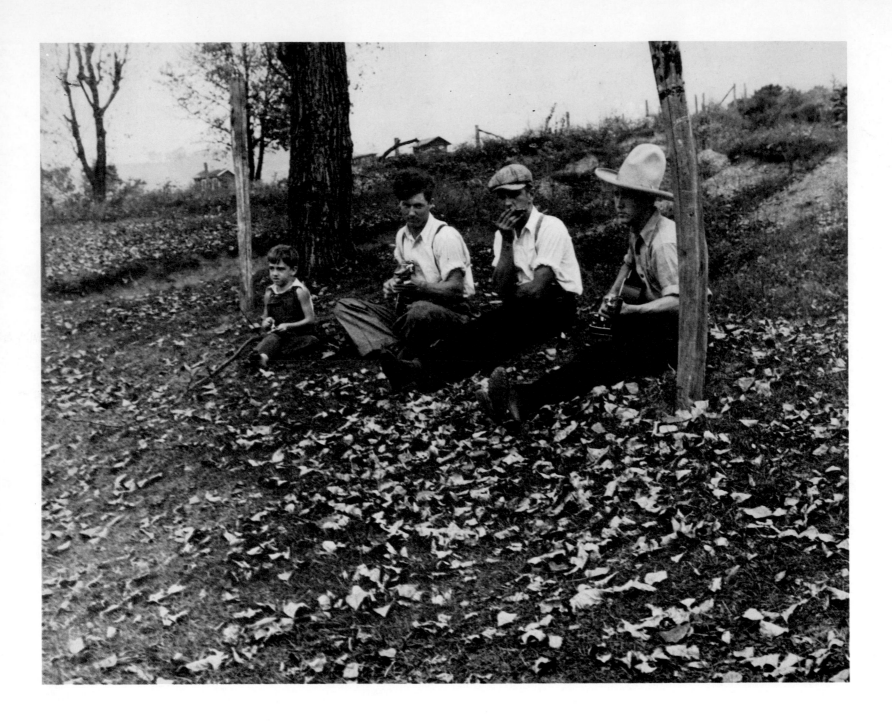

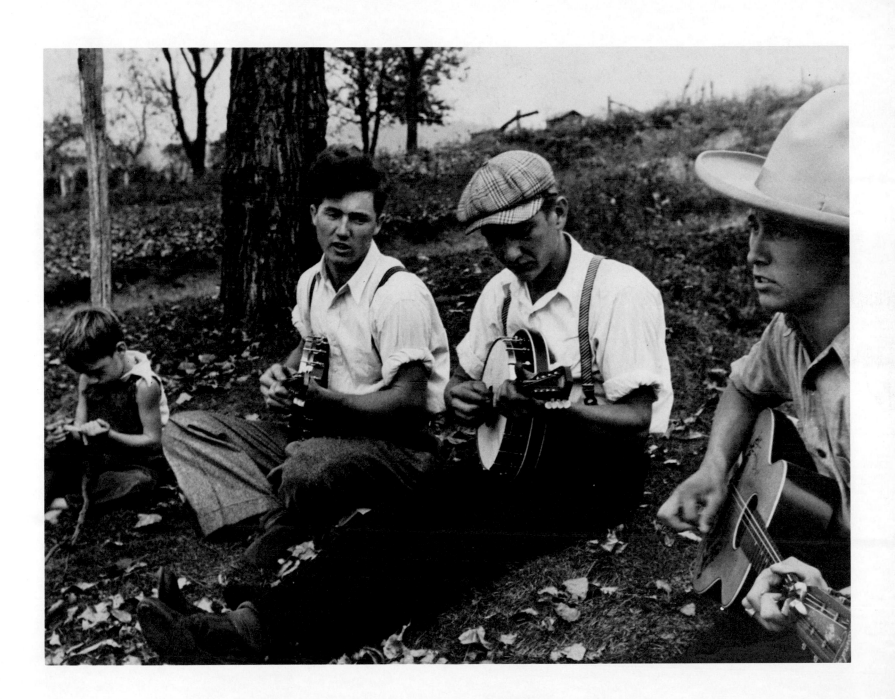

Musgrove brothers, Westmoreland County, Pennsylvania, 1935

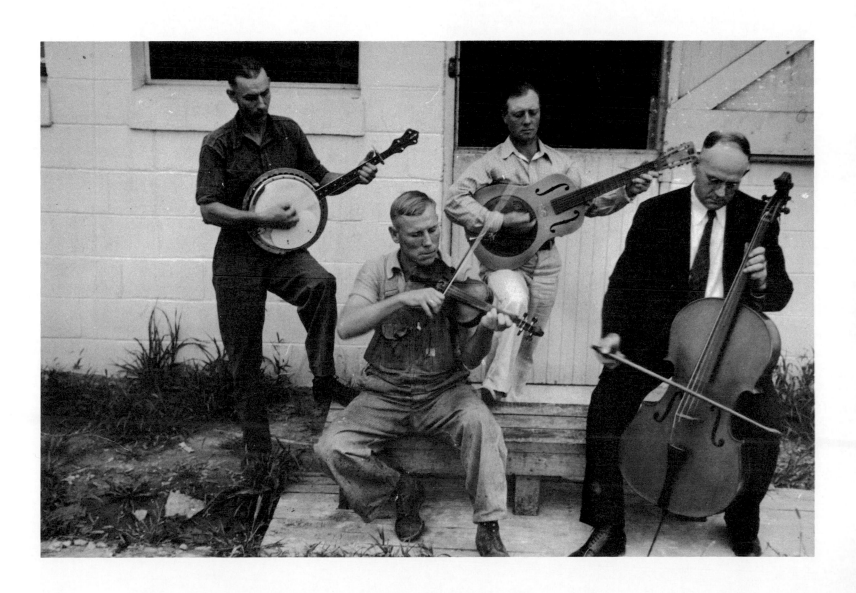

Practicing for the Westmoreland Fair, Pennsylvania, 1937

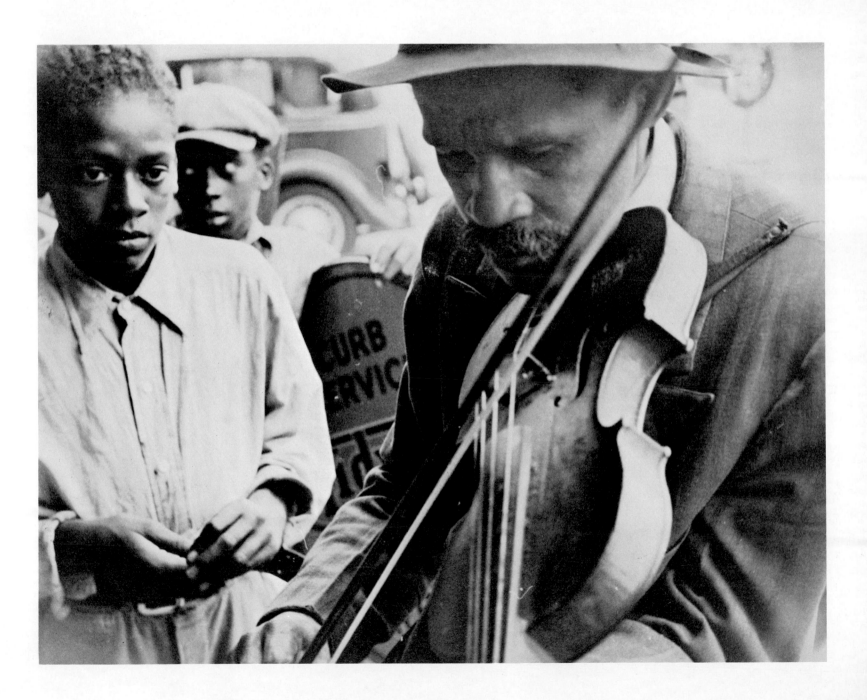

Blind street musician, West Memphis, Arkansas, 1935

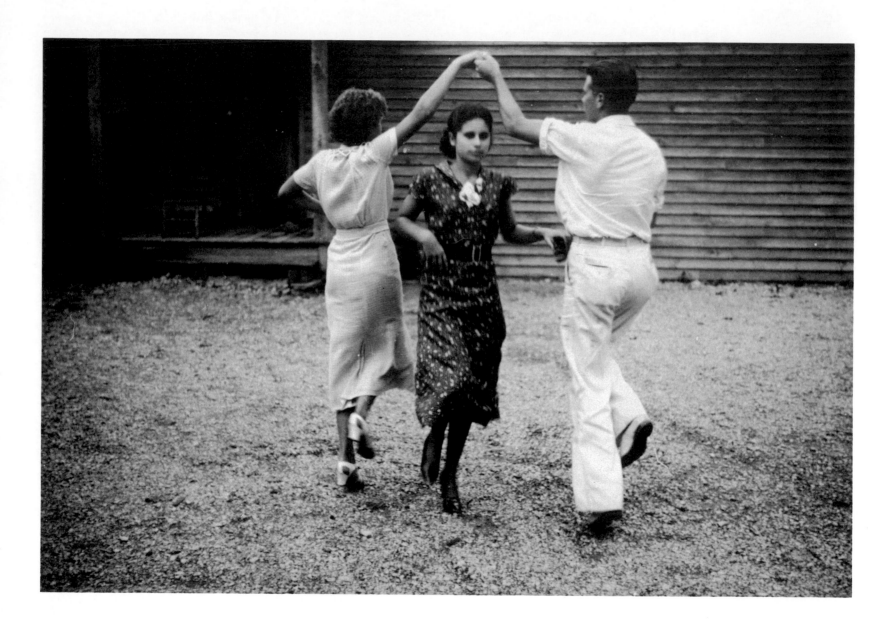

102 Dancers at Cumberland Homestead, Crossville, Tennessee, 1937

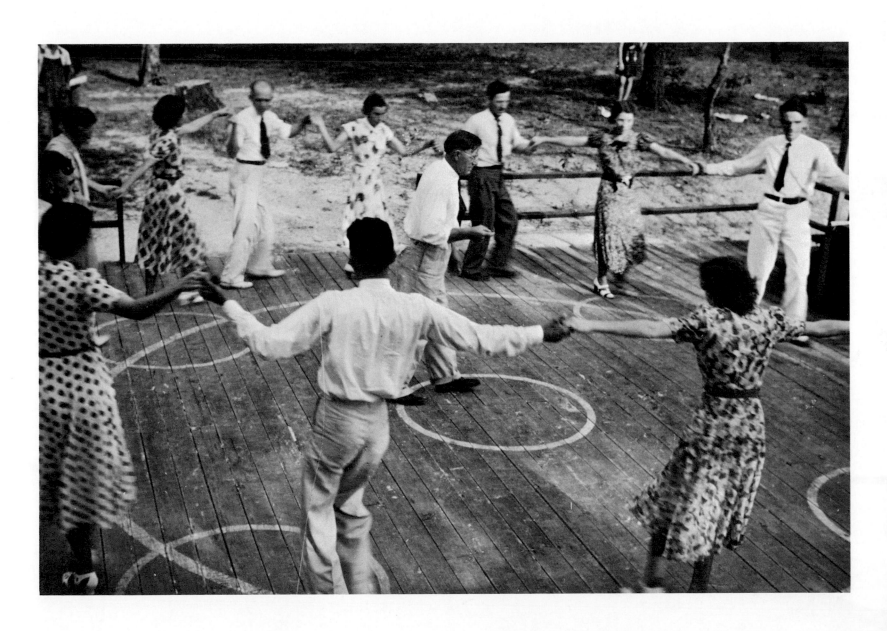

Square dance, Skyline Farms, Alabama, 1937 103

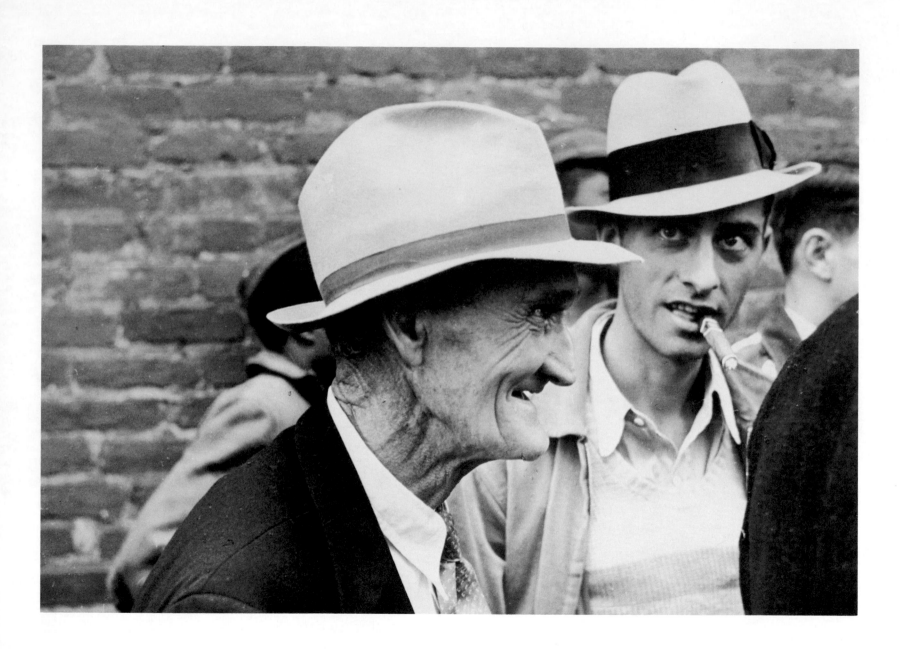

104 Medicine show audience, Huntingdon, Tennessee, 1935

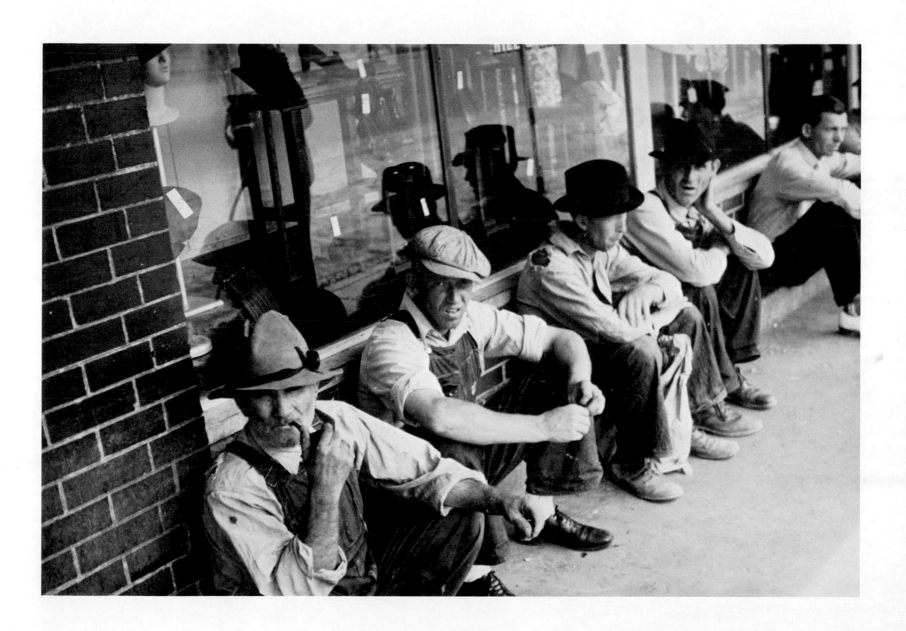

Sunday, Crossville, Tennessee, 1937 105

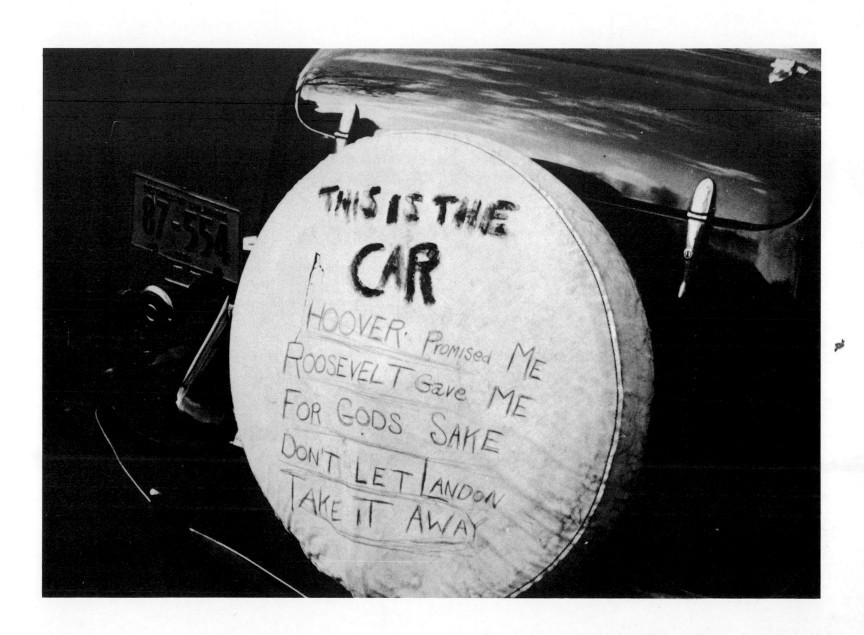

Sign on spare tire, Washington, D.C., 1936 107

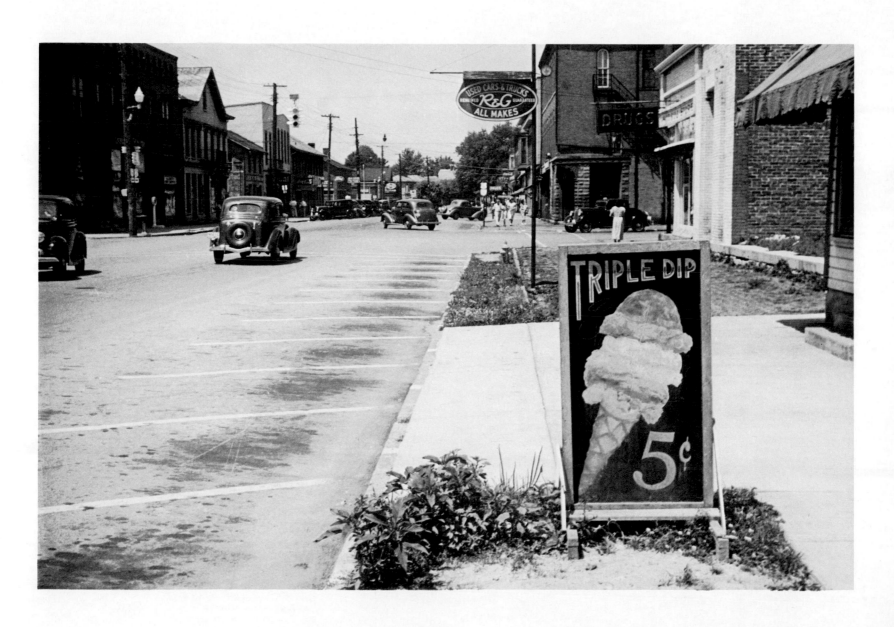

Main Street, Plain City, Ohio, 1938 109

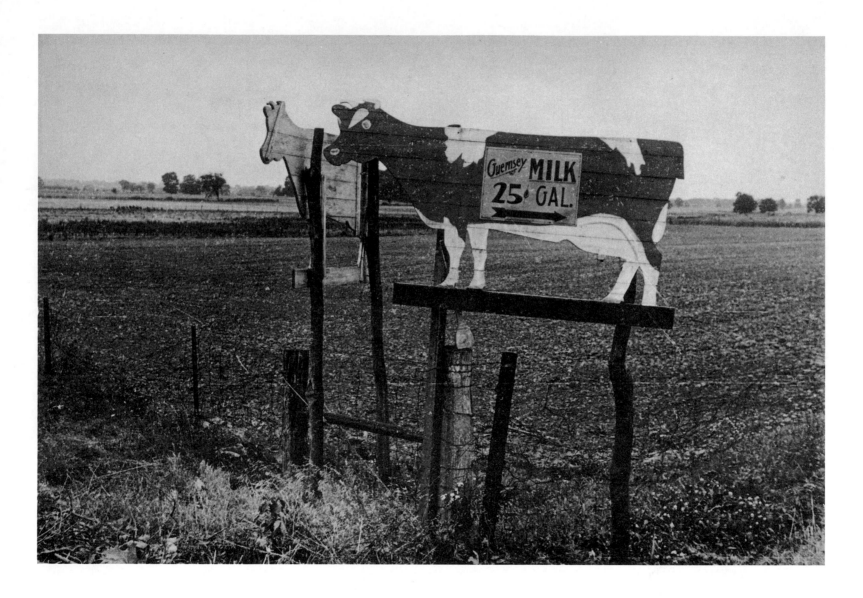

Sign, Route 40, central Ohio, 1938

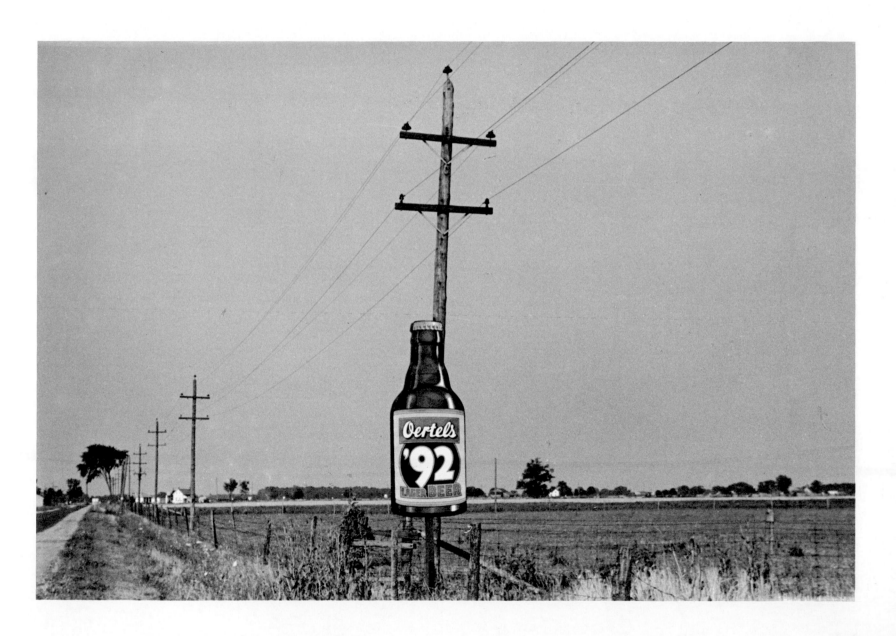

Sign, Route 40, central Ohio, 1938

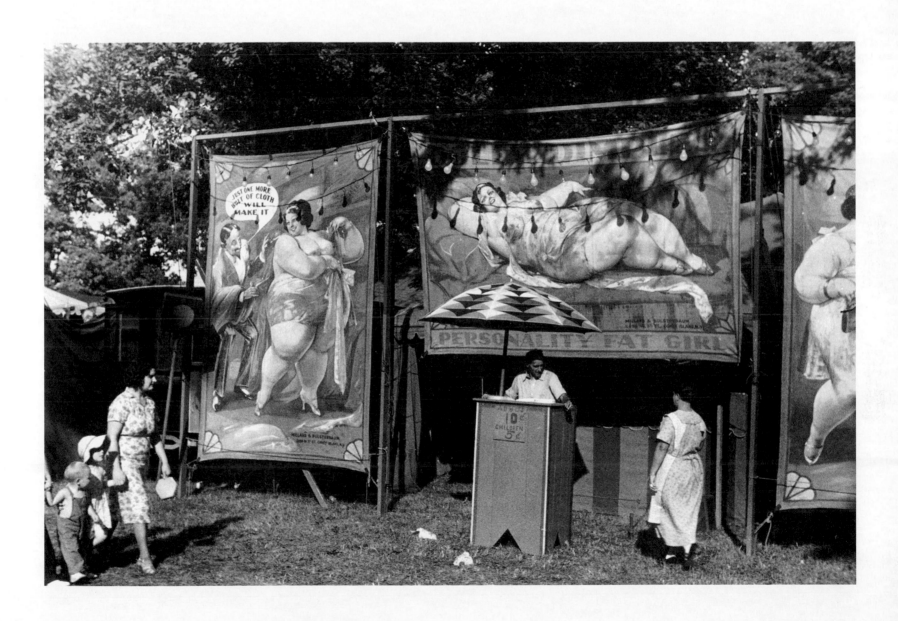

Side show, county fair, central Ohio, 1938

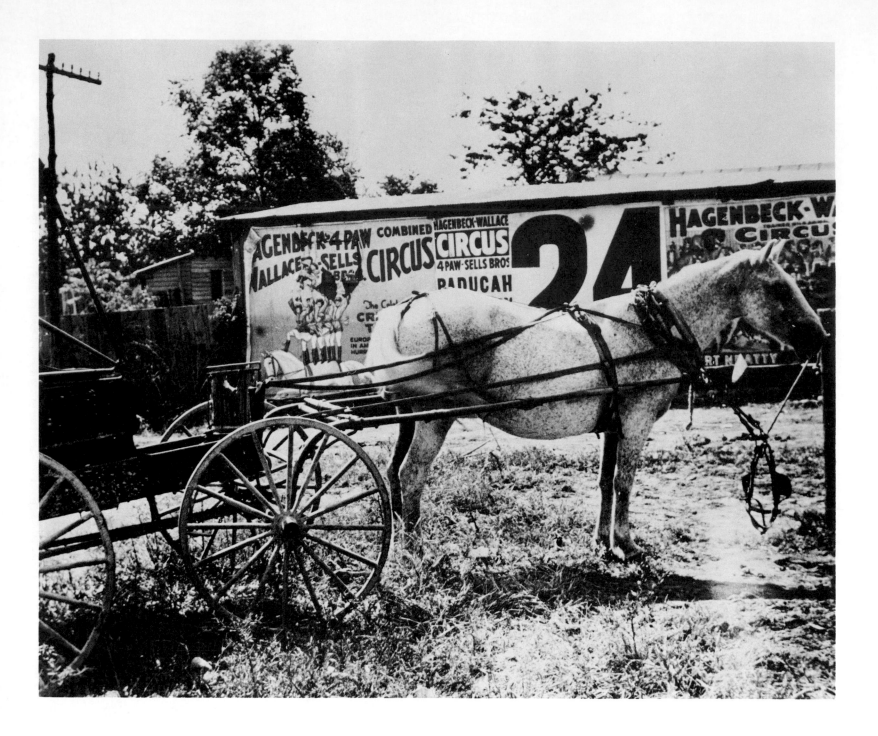

Circus poster, Smithland, Kentucky, 1935

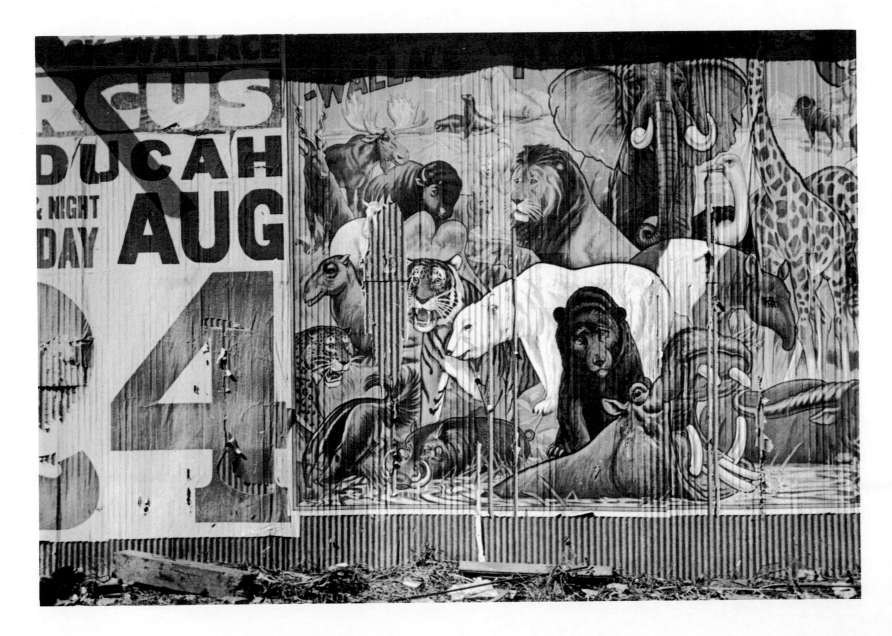

Circus poster, Smithland, Kentucky, 1935

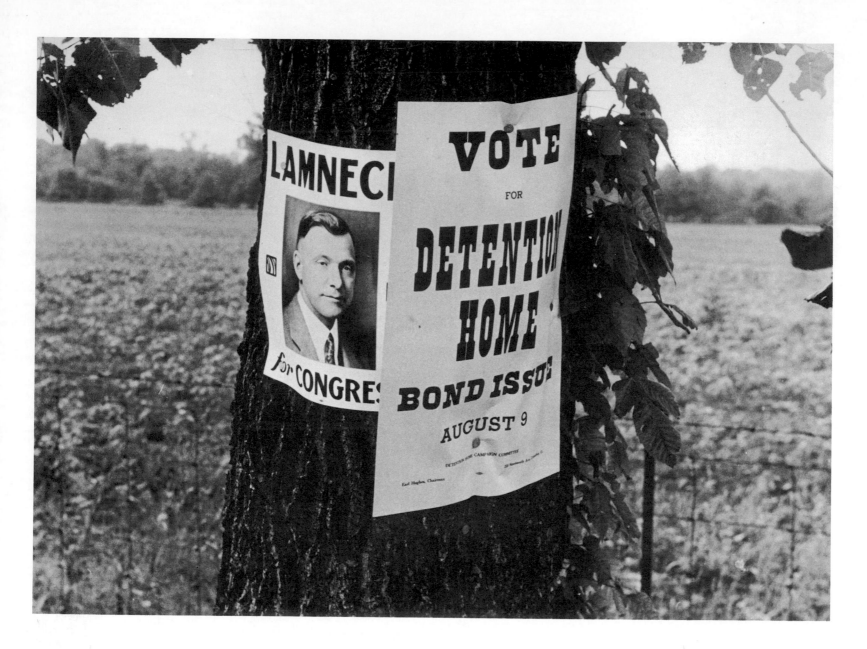

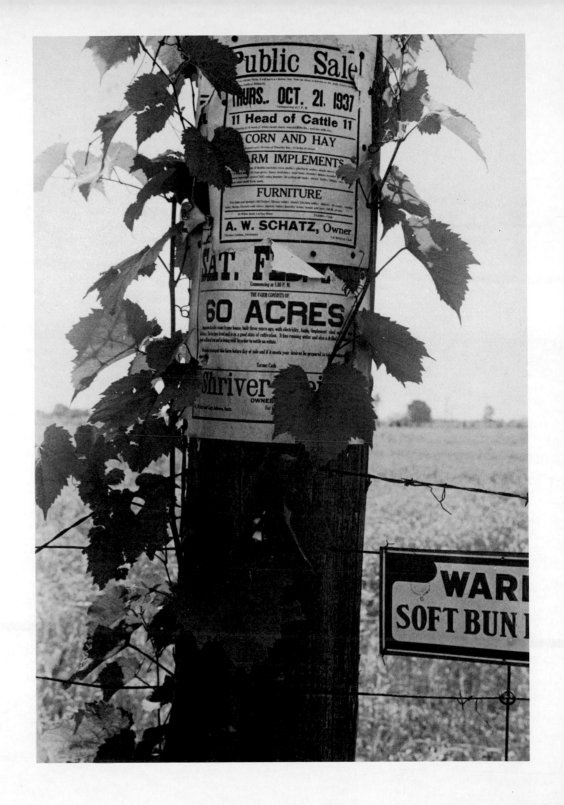

Along Route 40, central Ohio, 1938

117

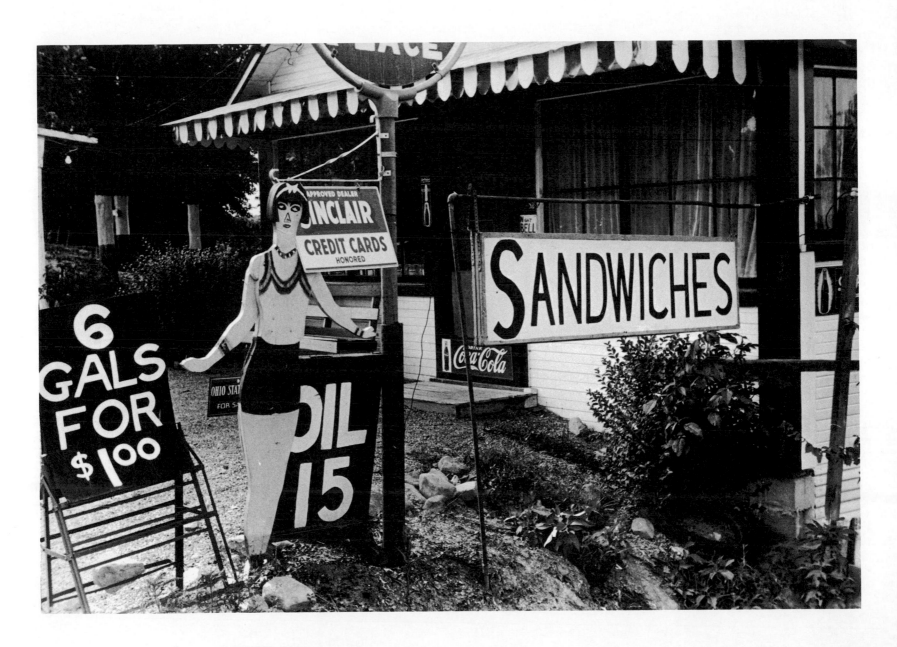

Roadside signs, central Ohio, 1938

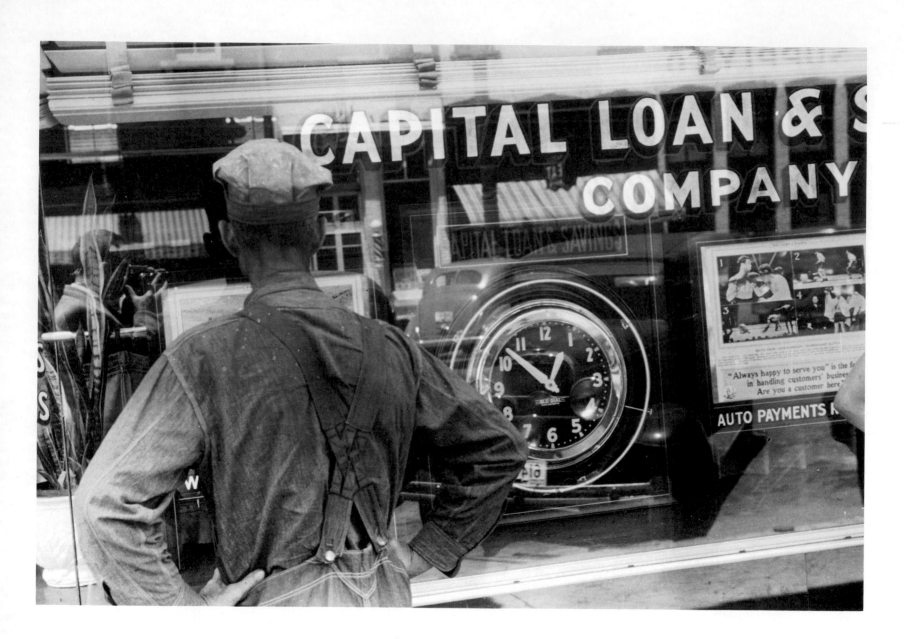

120 Street scene, Washington Court House, Ohio, 1938

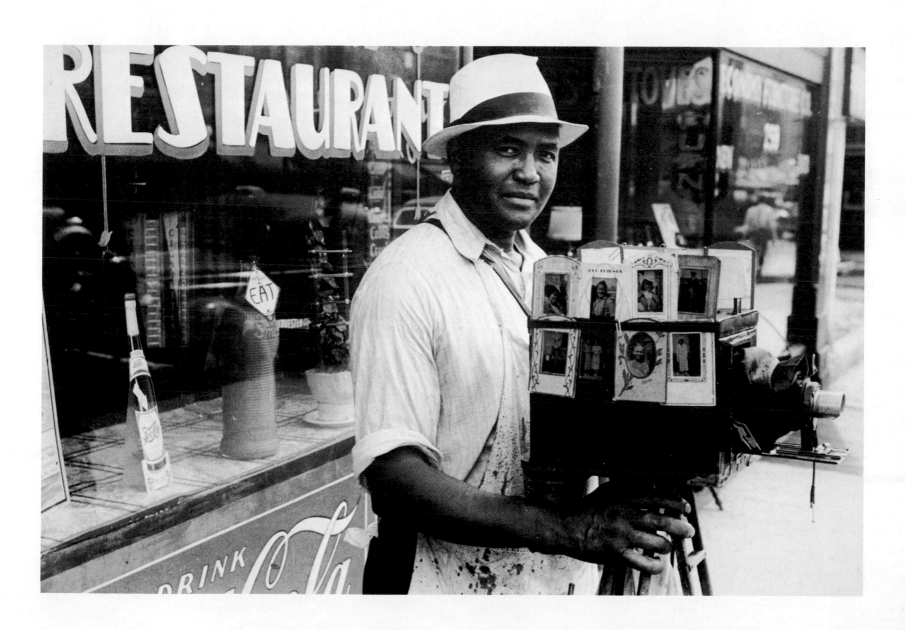

Itinerant photographer, Columbus, Ohio, 1938 121

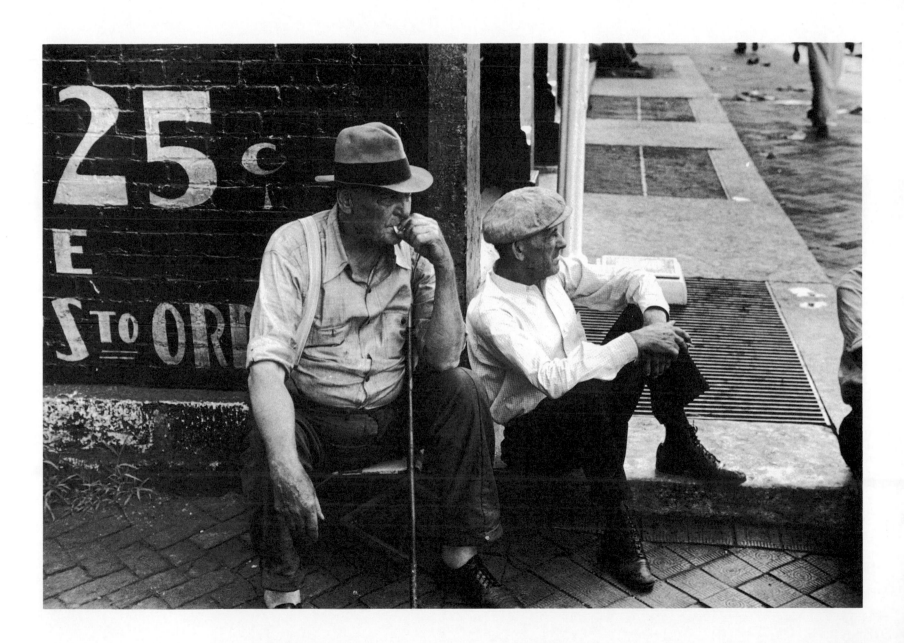

Residents of Columbus, Ohio, 1938

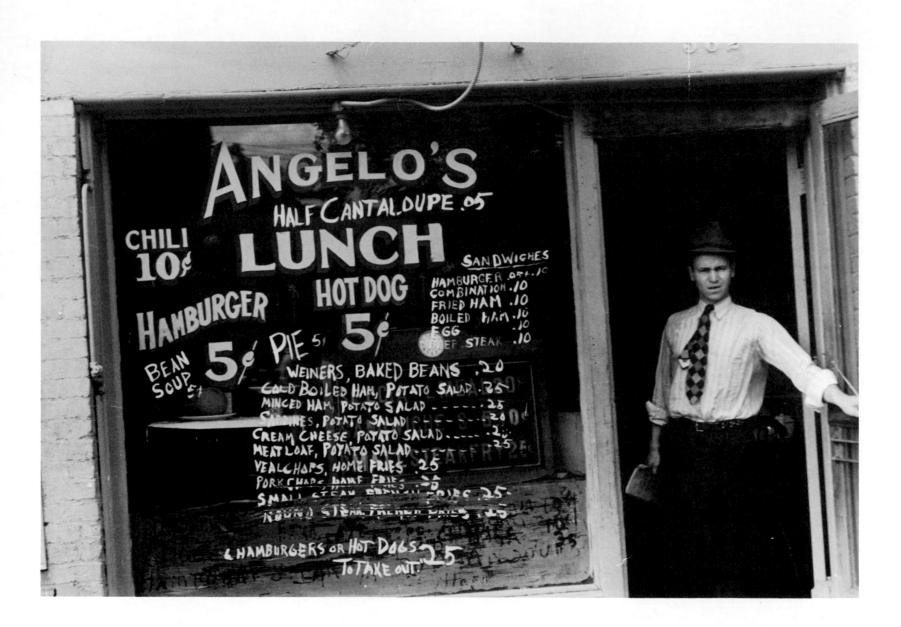

Lunchroom, Columbus, Ohio, 1938

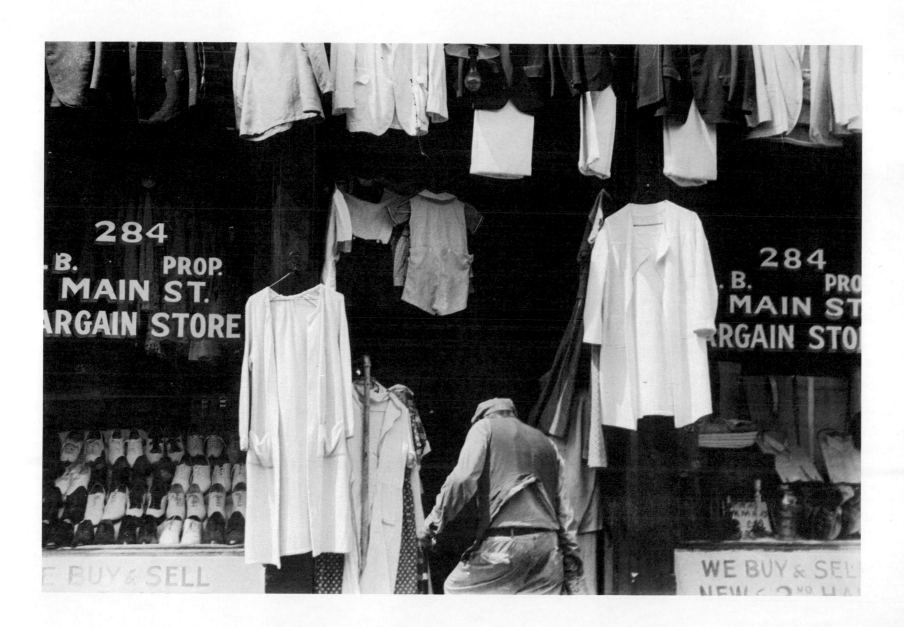

Secondhand clothing store, Columbus, Ohio, 1938

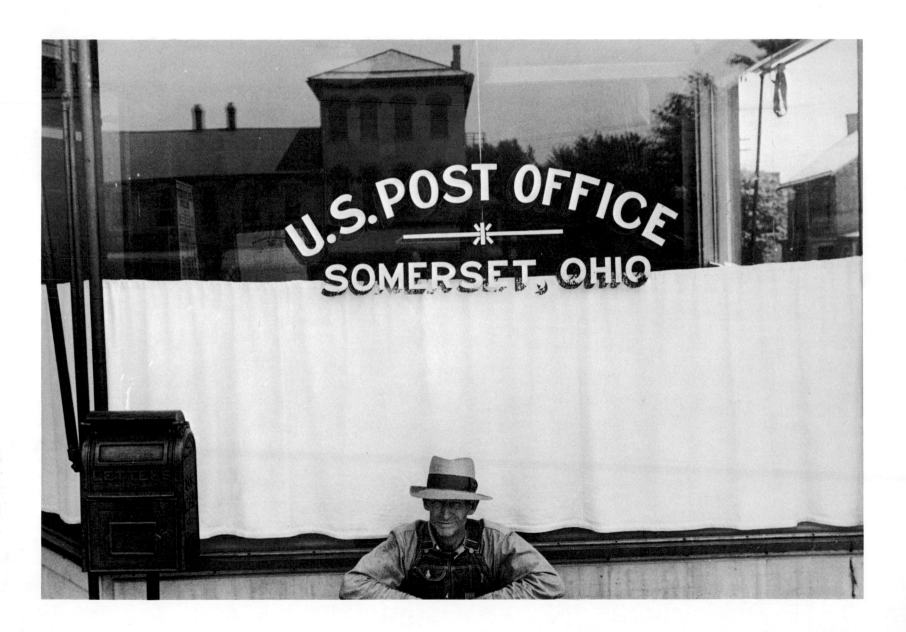

Post office, Somerset, Ohio, 1938 127

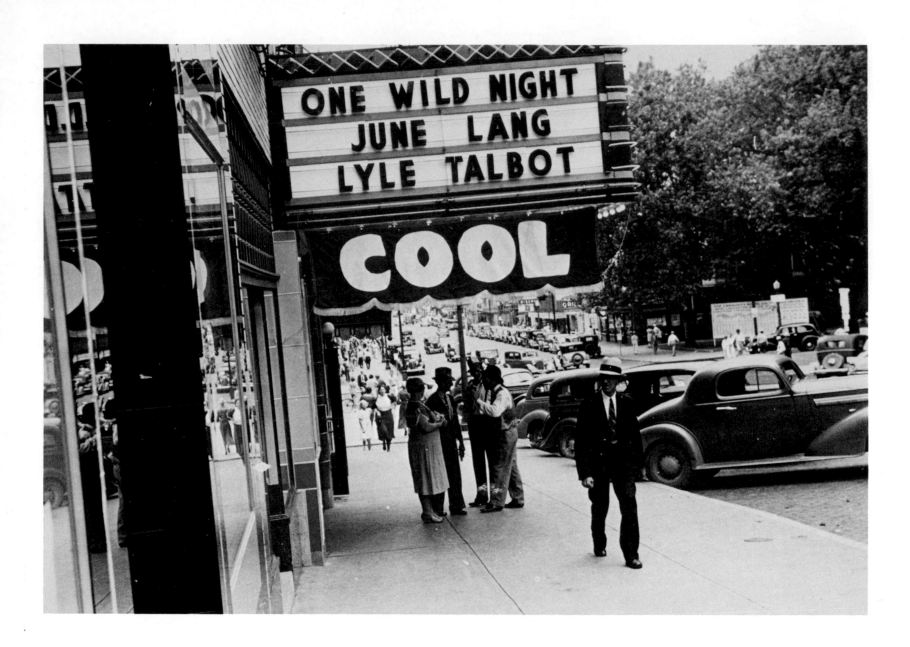

Street scene, Lancaster, Ohio, 1938

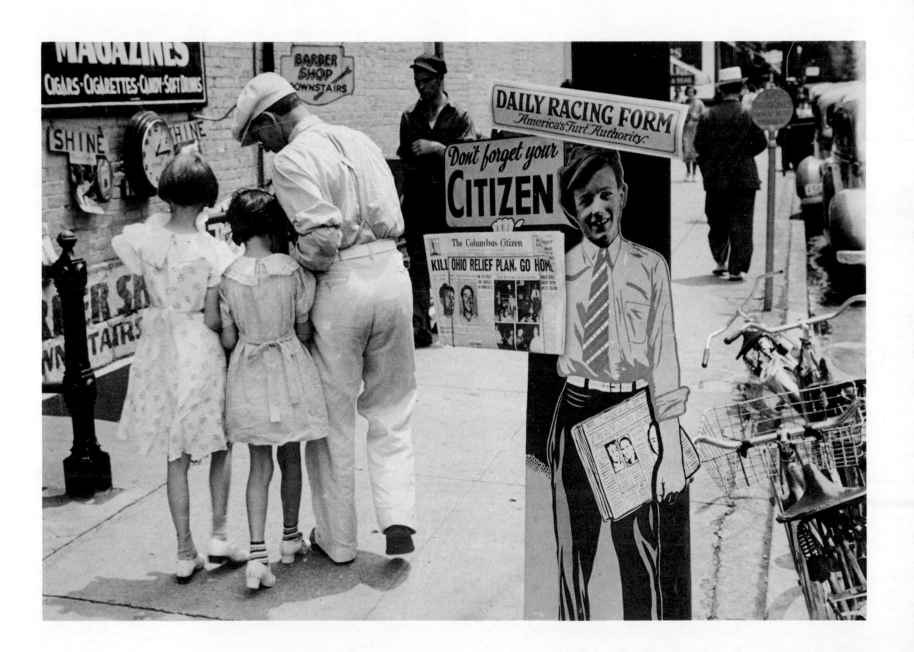

Main Street, Lancaster, Ohio, 1938

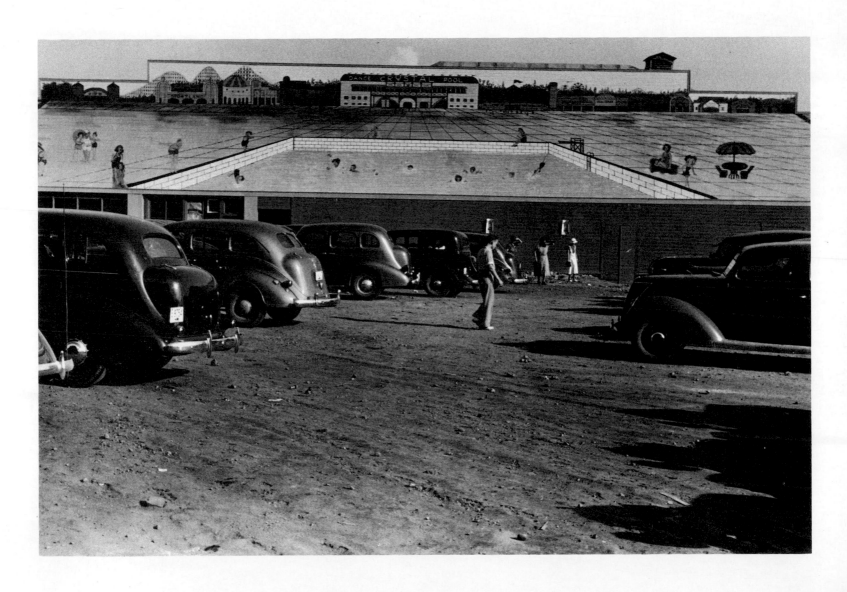

Convention hall mural, Buckeye Lake amusement park, Columbus, Ohio, 1938 133

Baled hay, central Ohio, 1938

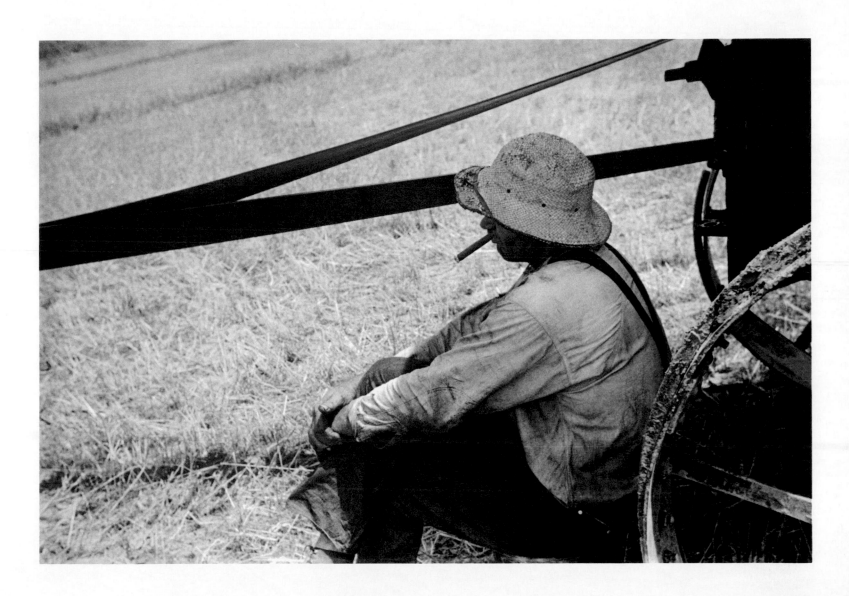

Member of threshing crew, central Ohio, 1938

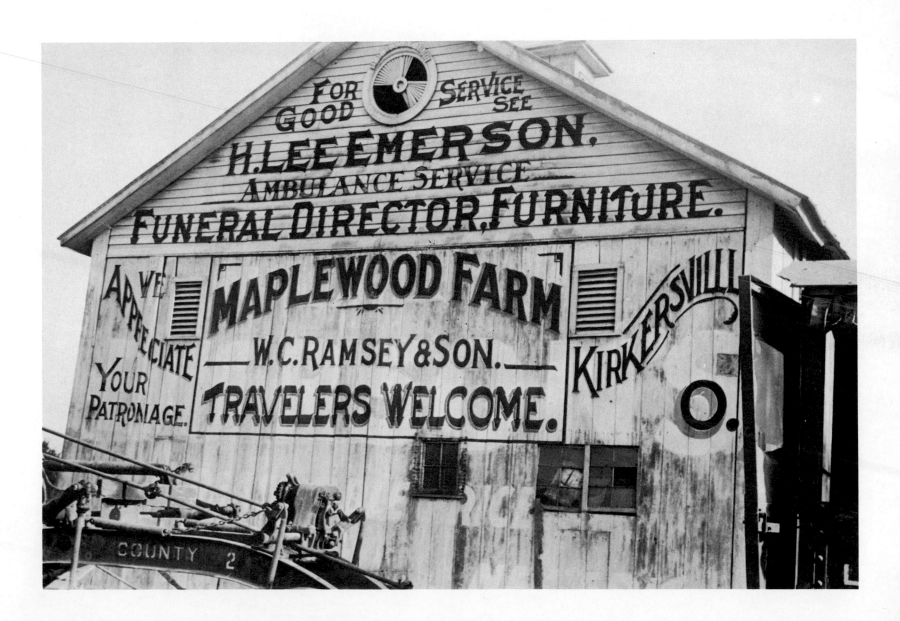

Maplewood Farm, Ohio, 1938

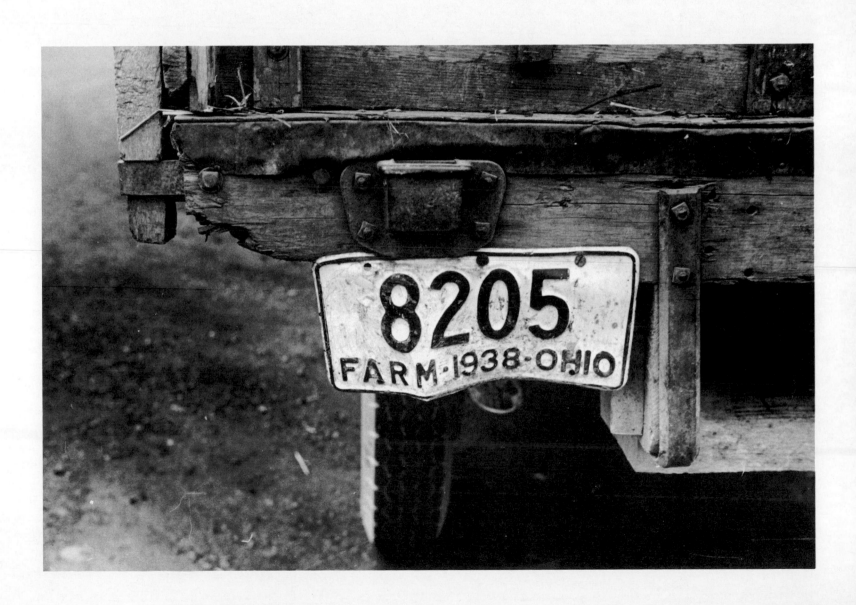

Route 40, central Ohio, 1938

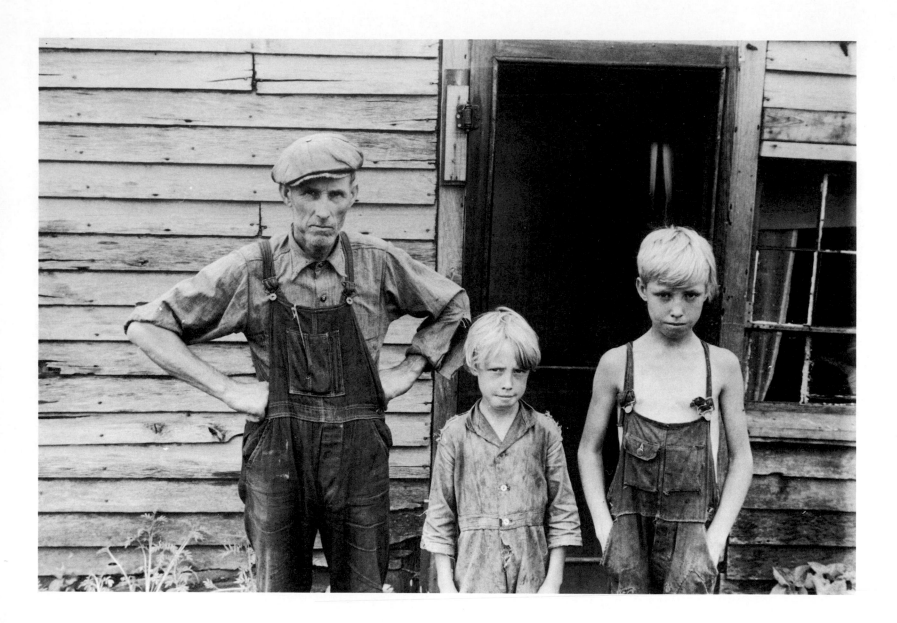

Family on relief, Urbana, Ohio, 1938

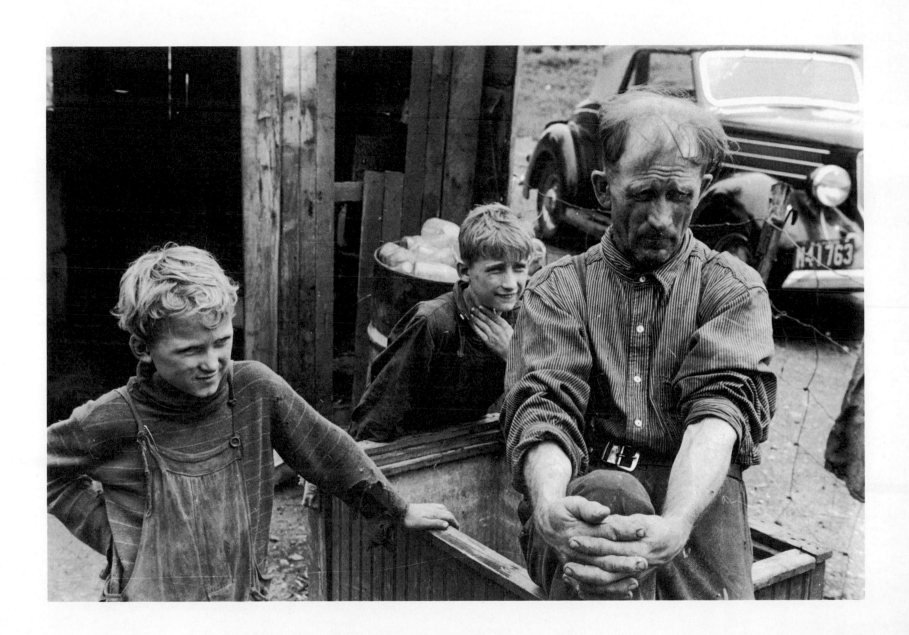

Ex-farmer and children on relief, central Ohio, August 1938

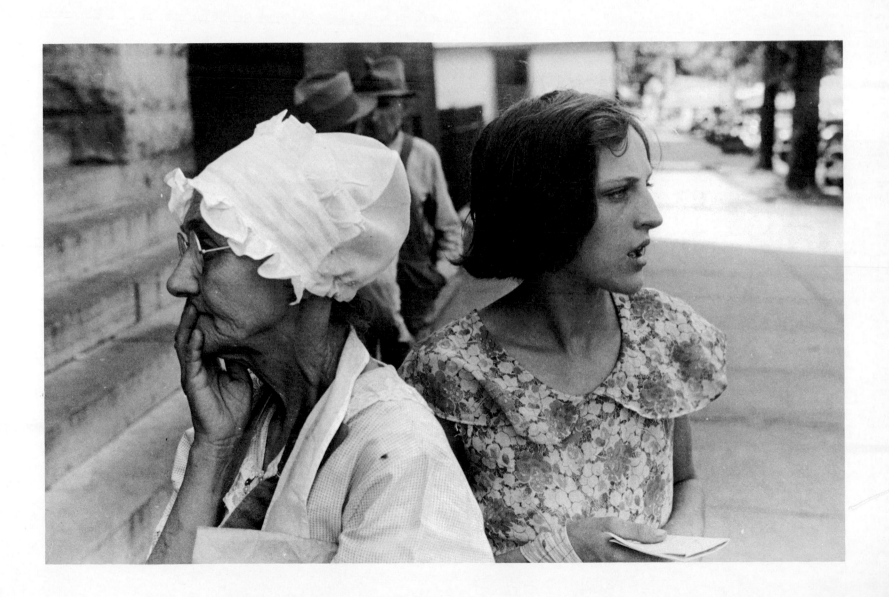

Waiting outside relief station, Urbana, Ohio, 1938

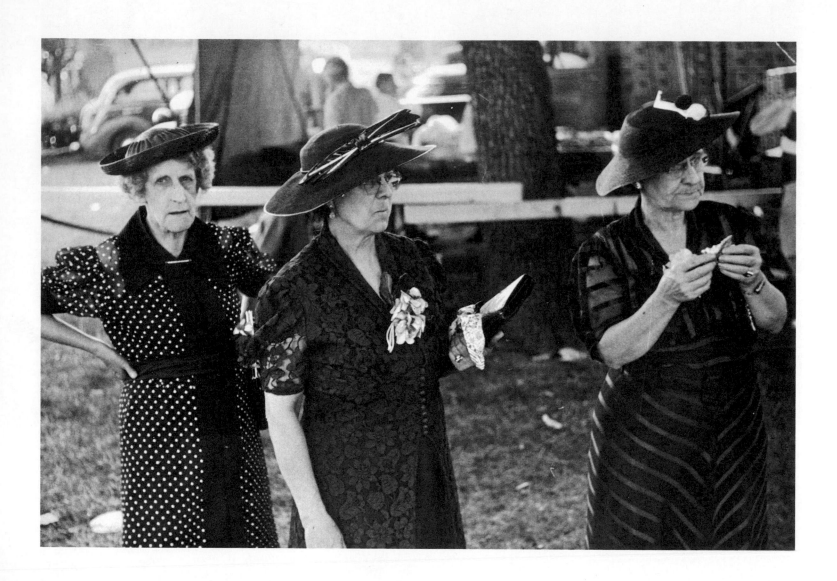

144 Fourth of July fish fry, Ashville, Ohio, 1938

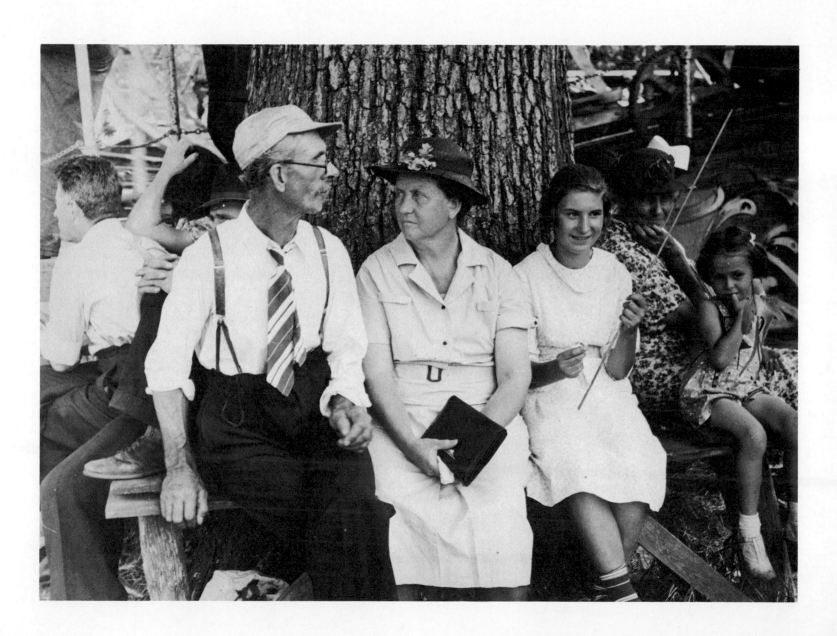

Farm people at the fair, central Ohio, 1938 145

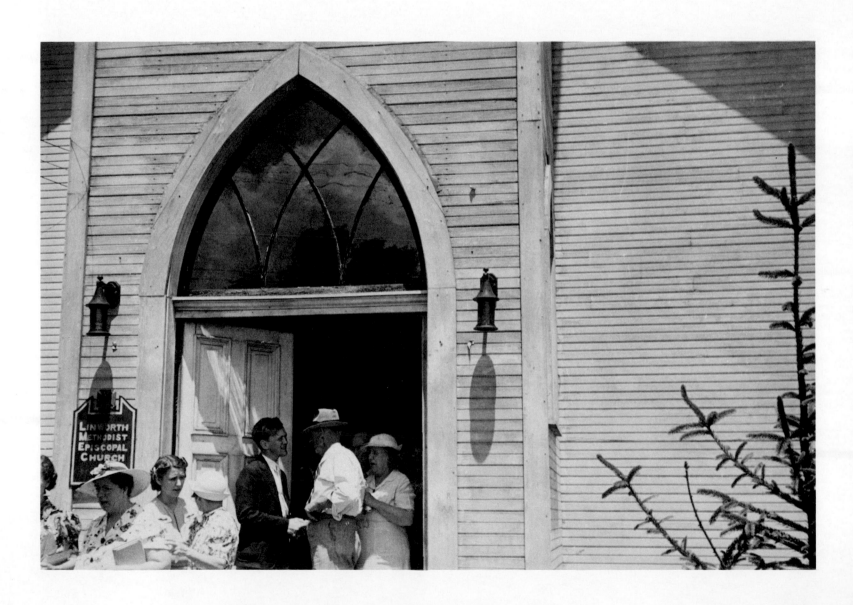

Linworth Methodist Episcopal Church, central Ohio, 1938

P 12-1-75
\# 06N0013
\#0584564